POSTCARD HISTORY SERIES

Wheeling

IN VINTAGE POSTCARDS

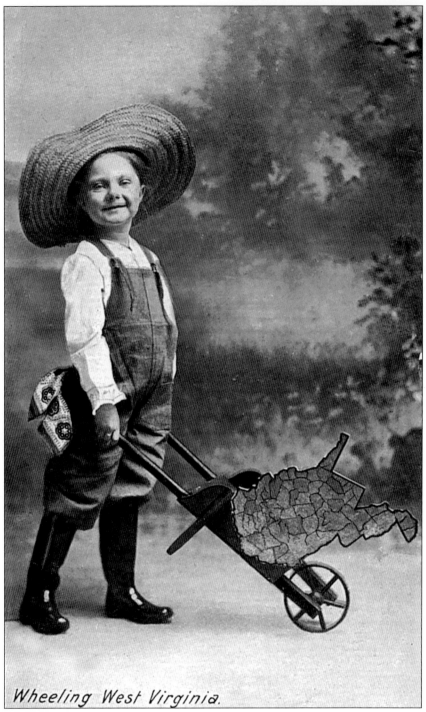

Wheeling West Virginia.

WHEELIN' WHEELING, 1904. Nerene Kirk, a four-year-old Wheeling girl, posed for a photograph that was made into this postcard. Her grandfather John H. Kirk owned the photography studio. Kirk's Photography was founded in 1877. The big occasion in Wheeling that day was the that the circus was coming to town.

POSTCARD HISTORY SERIES

Wheeling

IN VINTAGE POSTCARDS

William A. Carney Jr. and Brent E. Carney

ARCADIA

Published by Arcadia Publishing,
an imprint of Tempus Publishing, Inc.
2 Cumberland Street
Charleston, SC 29401

Printed in Great Britain.

Library of Congress Catalog Card Number: 2003104124

For all general information contact Arcadia Publishing at:
Telephone 843-853-2070
Fax 843-853-0044
E-Mail sales@arcadiapublishing.com

For customer service and orders:
Toll-Free 1-888-313-2665

Visit us on the internet at http://www.arcadiapublishing.com

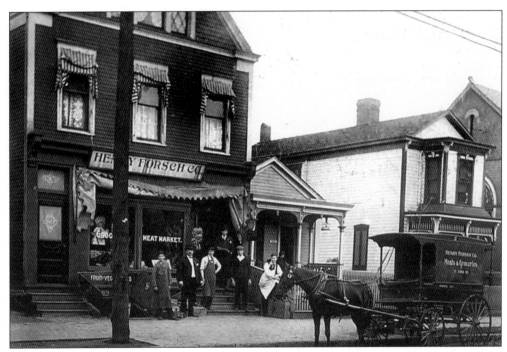

HENRY FORSCH CO. In 1894, Henry Forsch and Charles Seitter opened the Garden Spot Meat Market at 34 Zane Street. In 1903, Mr. Forsch began selling meats and groceries at 96 Zane Street. In 1907, he opened Henry Forsch Co. at 71 Zane Street. This photograph was probably taken between 1907 and 1910.

CONTENTS

ACKNOWLEDGMENTS

We would like to acknowledge the late Harry E. Parshall for starting the local postcard club. The base of our postcard collection as well as Harry's deep curiosity about this city's unique past was passed on to us. Over the years Ellen Dunable and Tony Paree have been a constant source of inspiration to those of us who enjoy searching for old Wheeling postcards. Margaret Brennan has single-handedly held the Wheeling Area Historical Society together. She deserves a lot of credit for making sure that the fragments of Wheeling's past are not scattered and forgotten. Sheila Carney endured a constant mess on her dining room table. Finally, we need to thank Rudy J. Agras and Ed Parshall for their technical assistance.

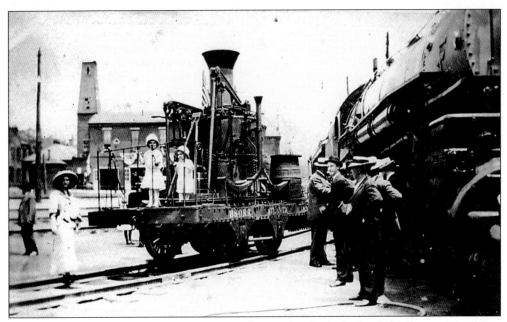

B&O *ATLANTIC*. In 1892, the Baltimore & Ohio Railroad rebuilt the 1836 locomotive *Andrew Jackson* to resemble the 1832 Phineas Davis locomotive *Atlantic*. It is a 2–2–0 Grasshopper engine. She was first exhibited at the World's Columbia Exposition in 1893 and is pictured above in Wheeling in June 1913.

INTRODUCTION

I can still remember my grandfather carrying a heavy cardboard box back and forth from his basement to his study. When I asked him what was inside he said, "Little stories about Wheeling." Later I figured out that it was his postcard collection. He would constantly separate the postcards into different Marsh Stogies boxes according to date, size, topic, and quality. My grandfather Harry Parshall saw these humble cards as something more than a way to say, "I'm on a vacation and you're not." He felt that these postcards were a unique, visual way to tell the story of Wheeling.

He was not the first person to see the value of postcards. In 1869, Dr. Emanuel Hermann began the concept that would later become the picture postcard. In 1893, the Columbia Exposition in Chicago went a long way to popularize the use of postcards. In the beginning of the 20th century, the penny postcard became even more familiar to ordinary people as it cost one cent to buy and another to mail. As means of transportation became more accessible, but without the aid of the telephone, e-mail, or fax, the postcard emerged as the preferable way to communicate while traveling. The zenith of the postcard's popularity seems to have been from 1900 to 1910 and many of our cards were made during that time. Each card gives but a glimpse of the location and scant room for a message, leaving the receiver's imagination to fill in the rest of the story. A postcard from an exotic locale such as Tahiti can inspire dreams of adventure while an old card from one's hometown can elicit an equal level of curiosity as to when and why our familiar town used to look so very different. Our book offers our younger readers a rare chance to see a completely flooded Wheeling as well a time when muddy, dirt roads ran through the center of town.

Wheeling is one of the most historically important cities in West Virginia and played a central role in its founding. Wheeling is an Native American word meaning "place of the scull" and served as a hunting ground for our local tribes. French troops under the command of Celoron de Blainville claimed the area for France in 1749. The French constantly battled the English for control of the region while attacks from Native Americans were frequent. Despite the turmoil, hearty families such as the Zanes, Boggs, Shepards, McCollochs, and Wetzels carved a small community out of the rugged terrain. This era provided Wheeling with some of its most cherished frontier stories. During a savage assault on Fort Henry in 1782, local woman Betty Zane saved the fort and all inside by dashing to retrieve gunpowder from a nearby cabin. She was not fired upon during the flight from the fort but received heavy flack on the return trip once the enemy realized that she had an apron full of powder. There was "Dirty" Simon Girty, who hunted with the Native Americans, and Lewis Wetzel, who hunted them mercilessly. Wetzel's notoriety reached all the way to the White House as President Theodore Roosevelt would later write in unflattering terms about Wetzel's methods. Maj. Samuel McColloch made a dramatic escape from Native Americans by jumping his horse off a steep 300-foot cliff. In July of 1782 the Native Americans captured and killed Major McColloch. They ate his heart so as to gain the courage of such a daring rider.

Wheeling grew exponentially during the 19th century and began developing its abundance of natural resources including coal and timber. During the Civil War, Wheeling sent many of its finest young men including the famed Carlin's Battery, 1st West Virginia Light Artillery. In 1861, the Reformed Government of Virginia was formed and Wheeling proudly served as its capital. Independence Hall on Market Street is considered the birthplace of West Virginia because it was the site of a series of events leading up to the state's creation by an act of Congress in 1863. The latter half of the century saw Wheeling become a major industrial center. The National Road brought Conestoga wagons and all their goods through Wheeling. The Ohio River brought a plethora of cargo by steamboat to our docks. The B&O Railroad brought even more products and people to our burgeoning city. The way west past the frontier came through our city and over the Wheeling Suspension Bridge. It was built between 1847 and 1849 and was the longest of its kind in the world when constructed.

By the time of World War I, citizens boasted that it had more millionaires than any other city of comparable size in the country. The ornate Victorian mansions, which still line our streets, hint that the boast might not have been far off the mark. We had influence in several different industries including tobacco, cut nails, glass, steel, iron, coal, and calico fabric. During the Jazz Age, Wheeling's underworld came to be dominated by the 400-plus-pound "Big" Bill Lias. This local gangster imitated many of Al Capone's methods to garner public support, such as giving away turkeys at Thanksgiving to the poor. He also supplied free coal when it was freezing and turned on the street hydrants when it was extremely humid. However, just like Capone, his feigned altruism was merely a cover for the nefarious and brutal underworld empire that he ruled.

In the years since World War II, Wheeling has emerged as the premier tourist destination in West Virginia. Many festivals and tours highlight the rich heritage of our city. Some of our tour guides talk about that "Wheeling feeling," which is very hard to pin down. In researching this book everyone seemed to have a different opinion about what that means but gave at least one good anecdote about Wheeling to give a piece of the city's puzzle. The city's wonderfully diverse ethnic makeup and advantageous geographic setting blend together to make Wheeling something unique. Wheeling is above the Mason Dixon line but also sent men south to the Confederacy and retains some of its Southern culture. Our relatives in Pittsburgh say that we have a Southern accent while our friends in Huntington swear that it is Northern. Wheeling was, for a time, the westernmost part of the eastern frontier. Wheeling is a blue-collar town that has some of the most delicate Victorian details on its private houses. Wheeling had mills, factories, smog, and coal dust just a few miles from the tranquil nature trails of Oglebay Park. The same town in which slaves were once sold at Center Market now celebrates the great contributions made by its African-American citizens such as Leon "Chu" Berry, James "Doc" White, and Phillip Nathaniel Reed. The same city that produced rugged sports heroes such as Chuck Howley also nurtured the angelic voice of opera star Eleanor Steber. Wheeling comfortably holds many contradictions and thus is hard to nail down. That's why a book of postcards, with their many different angles and views, seems like the appropriate place to start. We hope that in sharing these "Little stories about Wheeling" we can provide a few more pieces to the puzzle.

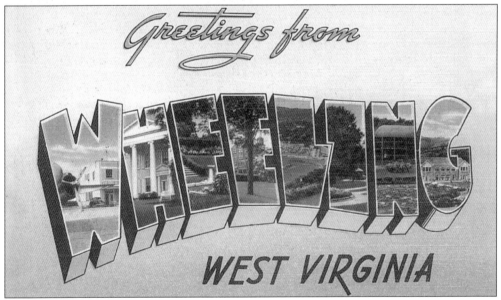

GREETINGS FROM WHEELING. Wheeling has become the top tourist destination for the entire state of West Virginia. The Victorian Wheeling Tours, Oglebayfest, the Italian Festival, the Festival of Lights, Wheeling Downs, West Virginia Independence Hall, and Jamboree in the Hills are just a few of the reasons people keep coming back to Wheeling.

One
HISTORY

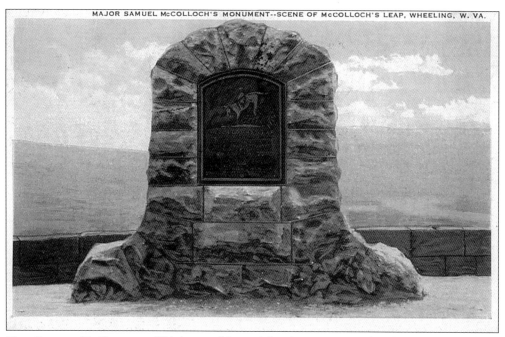

MAJOR SAMUEL McCOLLOCH'S MONUMENT--SCENE OF McCOLLOCH'S LEAP, WHEELING, W. VA.

MAJ. SAMUEL McCOLLOCH. This brave soldier and frontiersman survived a ride down this 300-foot cliff to escape from Indians in 1777. The Major was stationed at Van Meter's Fort at Short Creek. The monument, based on a painting by C. Young, who later died on the *Titanic*, is located on the top of Wheeling Hill.

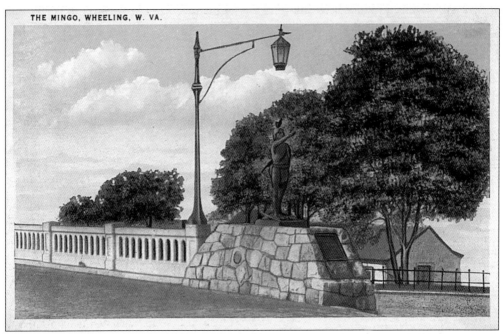

THE MINGO INDIAN. This statue stands along Old Route 40 at the top of Wheeling Hill and commemorates the Mingo Indians, who used Wheeling as a hunting ground. Wheeling is an Indian word meaning "place of the skull." The monument was designed by Henry Blue, a local glass designer, and was presented to the city of Wheeling in 1928 by the Kiwanis Club.

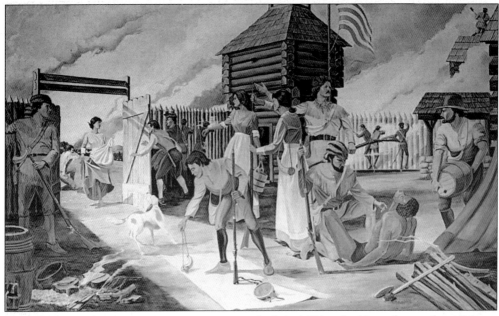

THE BATTLE OF FORT HENRY. Fort Henry was built in 1774 and withstood a number of sieges. The first was in September 1777 when the British led 300 Indians against the settlement. The last attack, in September 1782, was the last battle of the Revolutionary War. Depicted in this card is Betty Zane saving the fort by running for gunpowder, which she carried back to the troops in her apron.

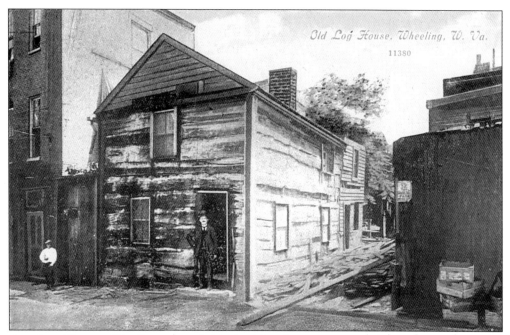

OLD LOG HOUSE. Wheeling was settled in 1769 by Ebenezer Zane and his brothers Jonathan and Silas, who blazed a trail from Redstone Old Fort (now Brownsville, Pennsylvania) through the wilderness until they reached the fertile bottom land at the junction of Wheeling Creek and the Ohio River. They initially called the area Zanesburg. This is believed to be one of their log cabins.

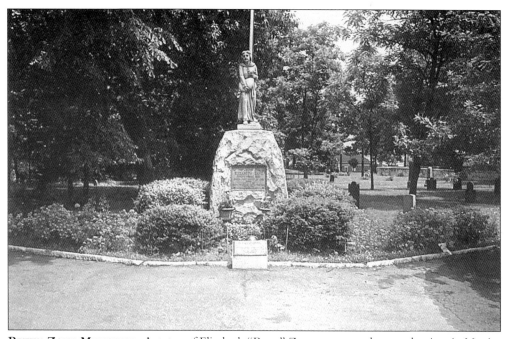

BETTY ZANE MEMORIAL. A statue of Elizabeth "Betty" Zane was erected across the river in Martins Ferry, Ohio. She was the heroine of the Battle of 1782 at Fort Henry in Wheeling. During World War II a United States liberty ship was named in her honor.

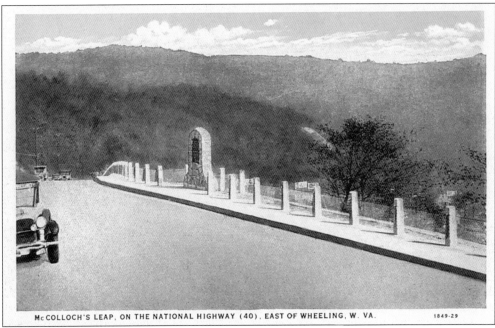

McCOLLOCH'S LEAP, ON THE NATIONAL HIGHWAY (40), EAST OF WHEELING, W. VA. 1849-29

McColloch's Leap. This statue commemorates the spot where Maj. Samuel McColloch narrowly escaped an Indian assault in 1777. Major McColloch had just led his troops into the safety of Fort Henry when he was cut-off by hostile Indians. He escaped only to be killed by the Indians in July 1782. To gain his courage the Indians cut-out his heart and ate it.

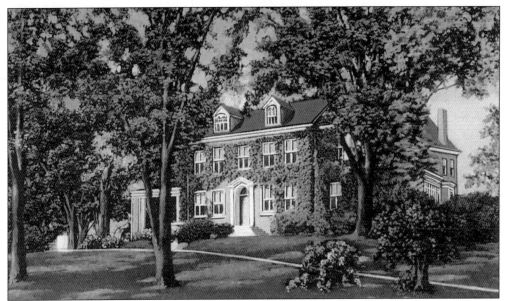

Monument Place. Monument Place was built by Col. Moses Shepherd in 1798 on the spot where Shepherd's fort stood. It was called Monument Place because of a statue in honor of Sen. Henry Clay which once graced the grounds. Visitors to the house included Presidents Monroe, Jackson, Harrison, Tyler, Polk, and Taylor. Other reputed callers were Daniel Webster, John C. Calhoun, and General and Mrs. Freemont. Lafayette stopped here on his travels in 1825.

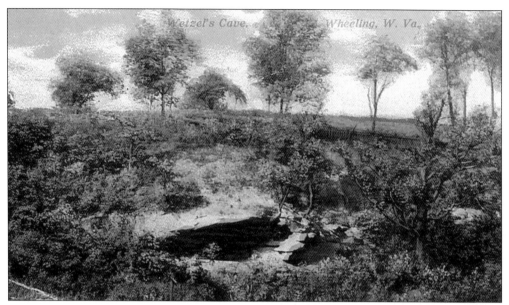

WETZEL'S CAVE. Renowned Virginia Ranger, scout, woodsman, and Indian fighter Lewis Wetzel killed at least one Indian on this spot who had been ambushing frontiersmen traveling along Wheeling Creek. President Theodore Roosevelt noted the exploits of Lewis Wetzel in his book, *The Winning of the West*, and Zane Grey wrote about his life in a number of his works. The Indians called him "Death Wind."

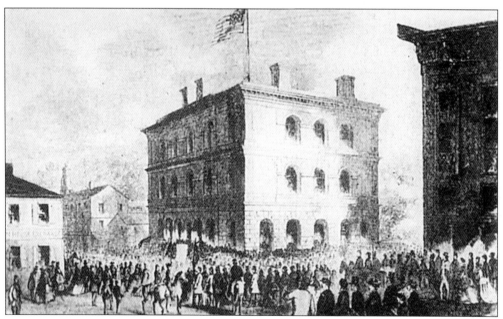

WHEELING CUSTOM HOUSE. The Wheeling Custom House, now West Virginia Independence Hall, was built at the corner of 16th and Market Streets in 1859. Due to Wheeling's economic prowess it became a "port of delivery" on the Ohio River. This meant that merchants could pay their duties in Wheeling rather than in New Orleans. The building played an important role in the statehood movement.

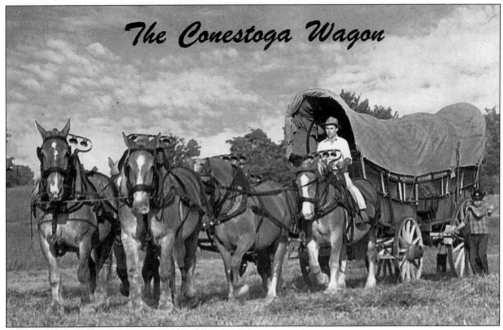

The Conestoga Wagon

CONESTOGA WAGON. Wagons of this type were made in Lancaster County, Pennsylvania and carried freight and families along the National Road through Wheeling and further west. Skilled craftsmen built the rugged "schooners," which opened the trails to California.

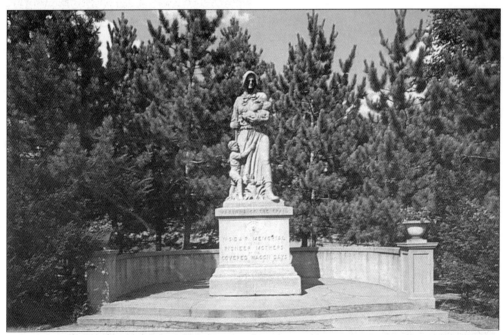

MADONNA OF THE TRAIL MONUMENT. This monument was dedicated on July 7, 1928 by the National Society of the Daughters of the American Revolution (D.A.R.). This Madonna is one of 12 placed along the National Road. It is located at the entrance to Wheeling Park and is a memorial to pioneer mothers who traveled along this road with their families.

HENRY CLAY MONUMENT. Moses and Lydia Shepherd erected this statue in 1820 in honor of the great legislator Henry Clay. He was responsible for convincing Congress to construct the National Road through Wheeling instead of Wellsburg, Virginia or Pittsburgh, Pennsylvania.

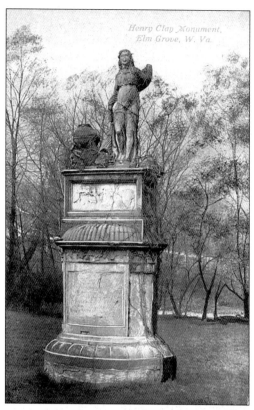

Henry Clay Monument, Elm Grove, W. Va.

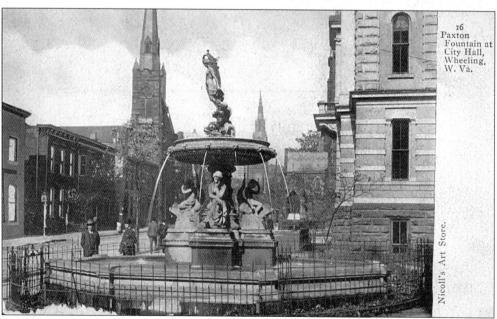

16
Paxton
Fountain at
City Hall,
Wheeling,
W. Va.

Nicoll's Art Store.

PAXTON FOUNTAIN AT CITY HALL. Wheeling resident James W. Paxton, a member of the convention that drafted West Virginia's constitution, presented this $10,000 two-basin fountain to the city in 1878. It was torn down in the 1950s at the same time as the courthouse.

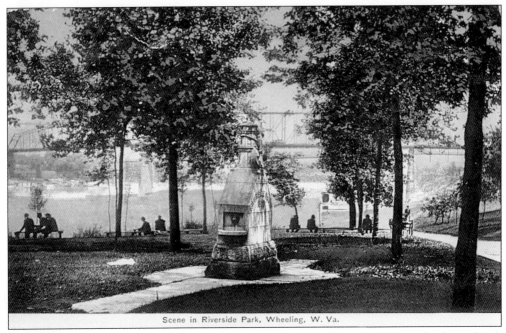

Scene in Riverside Park, Wheeling, W. Va.

RIVERSIDE PARK MONUMENT. The monument was placed in Riverside Park at the foot of 14th Street in 1900 to honor all those who served their country in time of war. It was donated by local beer brewer Henry Schmulbach.

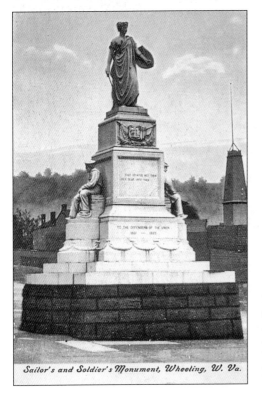

Sailor's and Soldier's Monument, Wheeling, W. Va.

SOLDIERS AND SAILORS MONUMENT. This statue was erected in 1880 on the southwest corner of the City County Building to honor the defenders of the Union during the Civil War. It was removed and placed in Wheeling Park in 1958.

Two
STREET SCENES

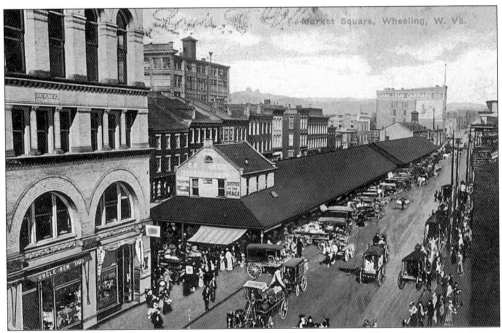

MARKET SQUARE, 1901. The Market House was built in 1822 at a cost of $686 and was where area farmers came to sell their produce. While Wheeling was still a part of antebellum Virginia, the far end of the building was used to auction slaves and, ironically, the near end housed the Justice of the Peace. The barely-visible buildings on the right side contained saloons and brothels. This Market House was replaced in 1912 with a new market.

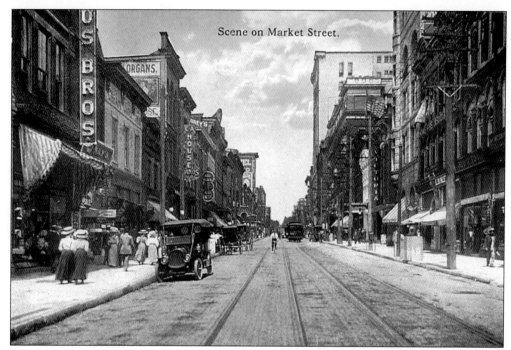

Scene on Market Street.

SCENE ON MARKET STREET. Wheeling was the main shopping center for the northern panhandle of West Virginia and eastern Ohio. The shopping district of Market and Main Streets had 5 department stores, 17 jewelers, 3 5&10 cent stores, and numerous other specialty stops and was the place for area shoppers to visit. Streetcars ran every few minutes from surrounding towns and villages.

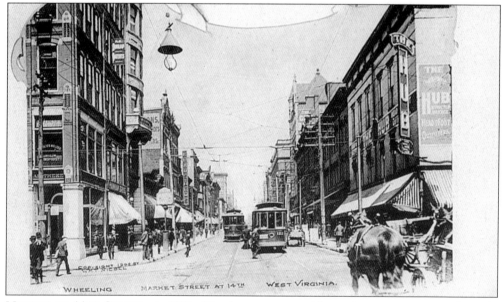

MARKET AT 14TH STREET, C. 1905. Wooden streetcars and horse-drawn-wagons were the main means of transportation. The Hub Department store is on the northeast corner. It was founded in 1891 by Moses Sonneborn. Starting with one room on this spot, it quickly grew and at one time ran from Market Street to Chapline Street.

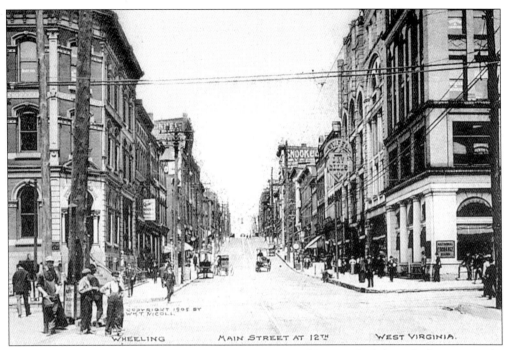

MARKET AND 12TH STREET, 1905. The Peoples Bank Building on the left was built in 1870. The bank was robbed of $1,536 on September 14, 1871. This event was mentioned in the *London Times* because a daylight robbery in those days was considered daring and rare, and because the clerk was shot at three times.

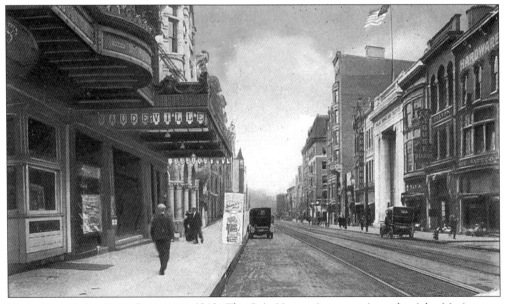

MAIN STREET LOOKING SOUTH, C. 1913. The C.A. House piano store is on the right. Music stores in Wheeling had an increase in business after floods due to the fact that one couldn't easily move pianos to the second floor during a flood. After the 1913 flood C.A. House had to burn 100 pianos that were damaged by the water. The average cost of each was $300.

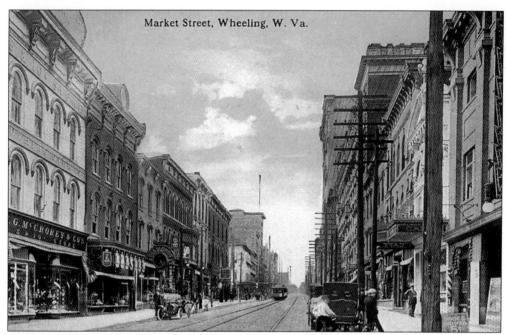

Market Street, Wheeling, W. Va.

MARKET STREET, C. 1910. On the left is McCrorey & Co., a 5&10-cent store, and next to it is the Charles Hancher Jewelry store with the locally famous Hancher clock in front. This timepiece was made by E. Howard & Co. of Boston in the 1880s. It has survived two traffic accidents and is still ticking in Wheeling today.

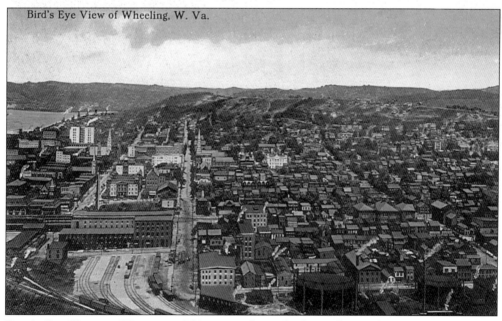

Bird's Eye View of Wheeling, W. Va.

BIRD'S EYE VIEW OF WHEELING. This view is from Chapline Hill around 1915. Public buildings, private homes, factories, warehouses, and railroads are mingled in this photograph of Wheeling when she was in her prime. The large cylindrical structure in the lower right corner was a gasometer at the city gasworks.

20

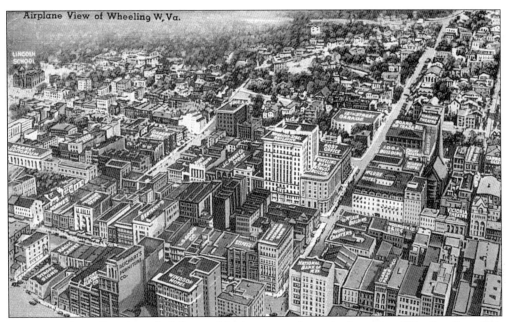

AIRPLANE VIEW. Prominent buildings and businesses are shown in downtown Wheeling from 10th to 14th Streets. The view dates from around 1940.

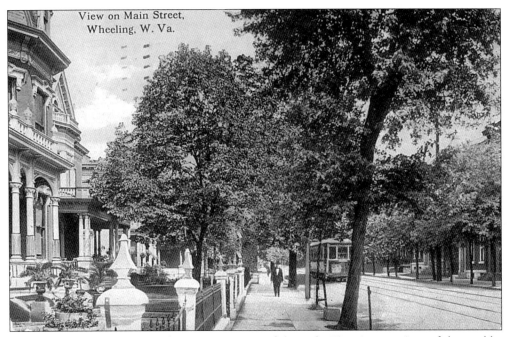

VIEW ON MAIN STREET. In this view are some of the early Victorian mansions of the wealthy industrialists, bankers, and store owners who lived along the street in the early 1900s. Today, Wheeling claims more than 600 Victorian buildings within the city limits. Citizens of the day used to argue that Wheeling had more millionaires than any city of comparable size in the country.

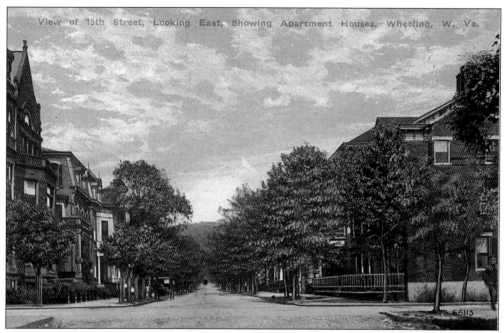

View of 15th Street, Looking East, Showing Apartment Houses, Wheeling, W. Va.

VIEW OF 15TH STREET, LOOKING EAST. This location is a block away from the courthouse and two blocks from the main shopping area. Some of the city's most affluent merchants and lawyers lived on the street. A local beer brewer lived in the corner house on the left. Note the boy dressed in the Linsly Military Institute's uniform.

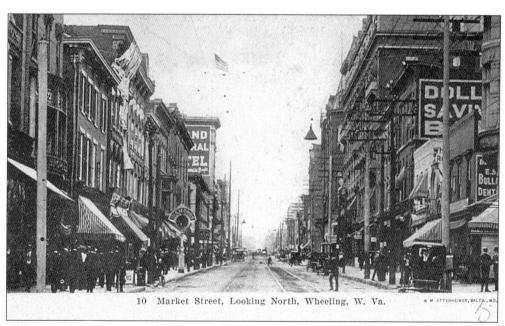

10 Market Street, Looking North, Wheeling, W. Va.

MARKET STREET, LOOKING NORTH, 1905. On any given shopping day there would be thousands of shoppers on Main and Market Streets. Private coaches brought the wealthy to town and street cars carried the rest of us. A number of families in Wheeling had chauffeur drivers in the 1920s and 1930s.

22

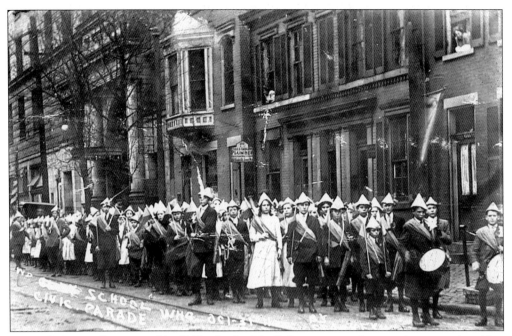

CIVIC PARADE, OCTOBER 31, 1911. At the Mardi Gras pageant the crowds were estimated at between 80,000 and 90,000 people. They lined Main and Market Streets to get a look at the floats and marchers. Every school was represented with a total of 2,000 children taking part.

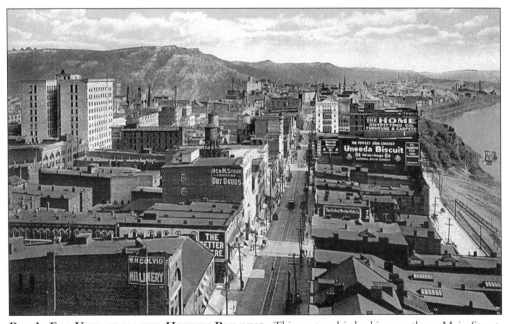

BIRD'S EYE VIEW FROM THE HAWLEY BUILDING. This postcard is looking south on Main Street. There are horses and buggies and a streetcar on the road. Note the advertisement for Uneeda Biscuits at 5 cents per package.

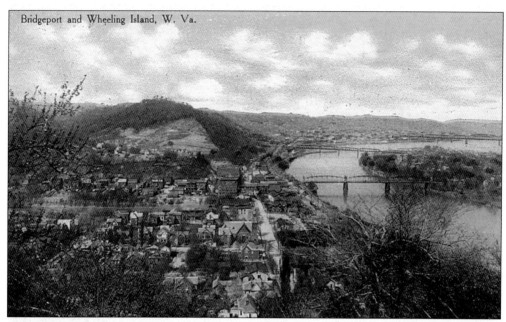

Bridgeport and Wheeling Island, W. Va.

BRIDGEPORT, OHIO AND WHEELING ISLAND. Bridgeport was settled by the same Ebenezer Zane who founded Wheeling. Some great athletes have graduated from Bridgeport High School including John Havilicek, who is in the NBA Hall of Fame; Joe and Phil Niekro, who play major league baseball; Bill Jobko of the NFL; Johnny Blatnik, a major league baseball player; and the Olympic wrestler and coach Bobby Douglas.

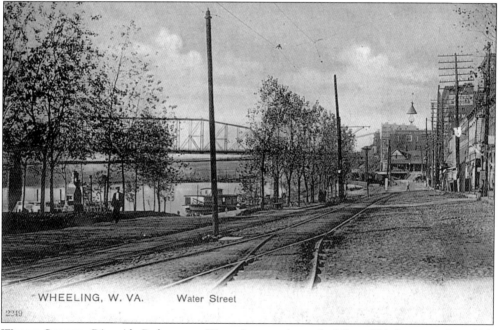

WHEELING, W. VA. Water Street

2249

WATER STREET. Riverside Park was on Water Street and stretched from 12th Street south to 14th Street. There were benches, trees, flowers, and a path to the Ohio River. Down on the water is the Booth and Crockard wharf boat. Note the unpaved street and the old-fashioned streetlight.

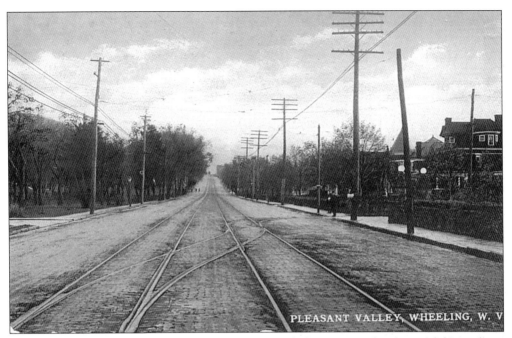

PLEASANT VALLEY, WHEELING, W. V

PLEASANT VALLEY. The completion of the Wheeling and Elm Grove Railroad opened this rural area to the building of great mansions. The Blochs, Stifels, Schenks, Goods, and others constructed huge homes along this avenue. Louis Mamakos also owned one of those huge homes. He started Louis' Famous Hot Dog Shop in 1919. (According to the author, one could get the best hot dog in the world!)

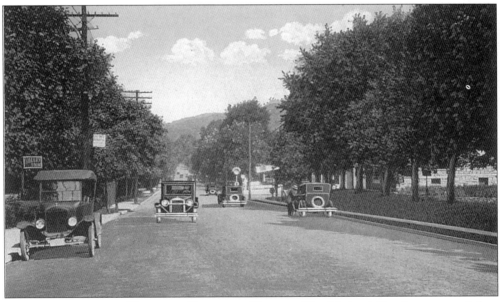

NATIONAL HIGHWAY THROUGH PLEASANT VALLEY. The National Road was extended to Wheeling in 1818 and helped to make Wheeling a transportation and industrial center. The road started in Cumberland, Maryland and was the first federally financed highway in the country. It was completed to Vandalia, Illinois in 1839. For over 50 years it was the busiest highway in the country.

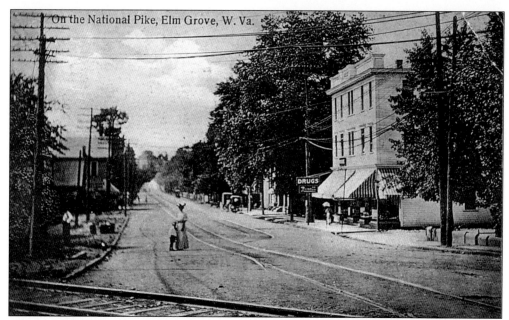

ON THE NATIONAL PIKE, ELM GROVE. This is the intersection of Wheeling and Elm Grove Railroad (streetcars), and the B&O Railroad. Note the lady with the parasol in front of the Moore Rexall Drugstore.

WARWOOD AVENUE, WARWOOD. This small town bordering the north side of Wheeling was incorporated in 1911 and became a part of Wheeling in 1920. Metropolitan Opera star Eleanor Steber and Super Bowl V MVP Chuch Howley both grew up in this town.

Three
RIVER AND RAILS

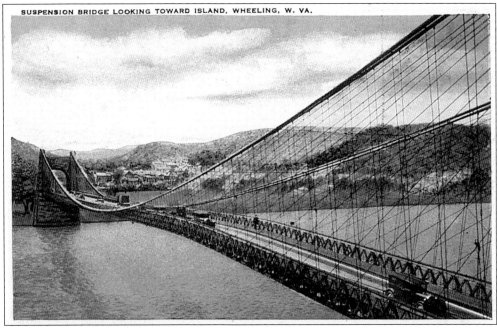

SUSPENSION BRIDGE LOOKING TOWARD ISLAND, WHEELING, W. VA.

WHEELING SUSPENSION BRIDGE. The Wheeling Suspension Bridge was built by the eminent civil engineer Charles Ellet Jr. between 1847 and 1849. It spans 1010 feet across the Ohio River and was the longest of its kind in the world when constructed. Today it is the oldest suspension bridge in the western hemisphere and is a national historic landmark and civil engineering landmark. It is still in use today.

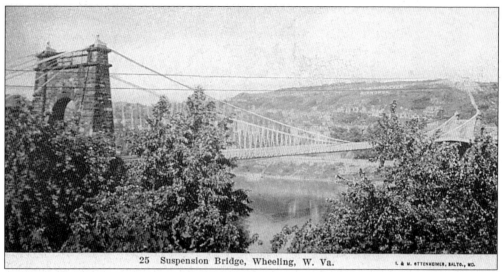

25 Suspension Bridge, Wheeling, W. Va.

SUSPENSION BRIDGE. Less than four years after the great suspension bridge was dedicated it was blown down in a violent wind storm. Charles Ellet Jr. returned and rebuilt the structure, strengthening the span with stay cables. Local tradition tells us that "Jumbo," the huge circus elephant, would not cross the bridge because he could feel it swaying.

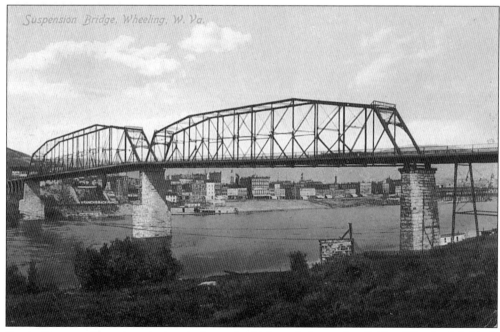

Suspension Bridge, Wheeling, W. Va.

STEEL BRIDGE. Note the mistake on the card which reads Suspension Bridge. The Steel Bridge's construction began in 1891 and was built to carry streetcars. It crossed the river from Ohio Street on Wheeling Island to Bridge Street in downtown Wheeling and was razed in 1962.

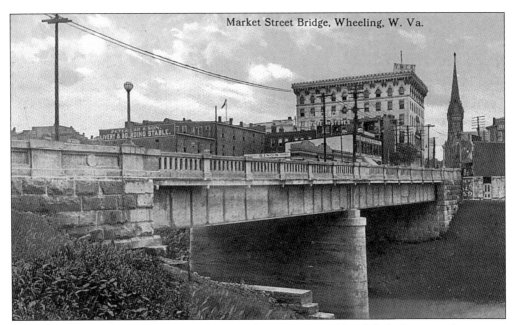

Market Street Bridge, Wheeling, W. Va.

MARKET STREET BRIDGE, C. 1912. The St. Alphonsus German Church is the large steeple structure to the right. The YMCA was completed in 1910. The bridge extended to Market Street from the shopping district across Wheeling Creek into the center of town.

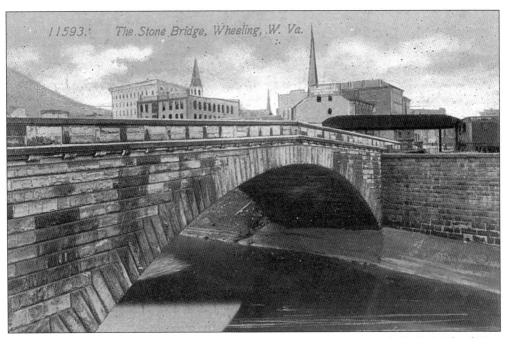

11593. The Stone Bridge, Wheeling, W. Va.

STONE BRIDGE. This bridge was designed by the engineers F.L. Hoge, and W.C. Smith of New York. The stone for this arc bridge came from the stone quarry of William Carney. When completed in 1892, it was the longest single-span stone bridge in the country.

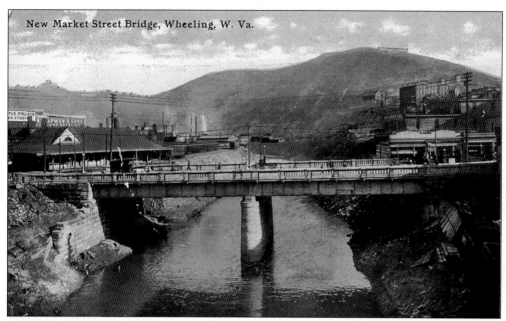

New Market Street Bridge, Wheeling, W. Va.

NEW MARKET STREET BRIDGE. This is near the mouth of Wheeling Creek where it is said that French explorer Pierre-Joseph Celoran de Blainville claimed this land for France in 1749 by burying a lead plate. That plate has never been found. In the distance is the Augustus Pollock Stogie factory. His firm made the well-known Crown Stogies.

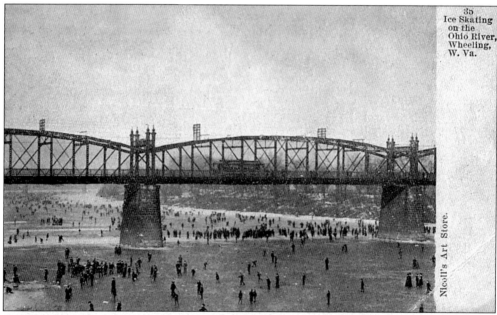

35
Ice Skating
on the
Ohio River,
Wheeling,
W. Va.

Nicoll's Art Store.

ICE SKATING ON THE OHIO. Thousands of people are shown skating and having fun on the frozen back channel of the Ohio river between Bridgeport, Ohio and Wheeling Island. The river would freeze over almost every winter and, when found to be safe enough, the local citizens made use of the area. It is said that even a baseball game was played on the surface. The bridge was erected in 1893 for the Wheeling-Belmont Bridge Co. and replaced an old wooden covered bridge.

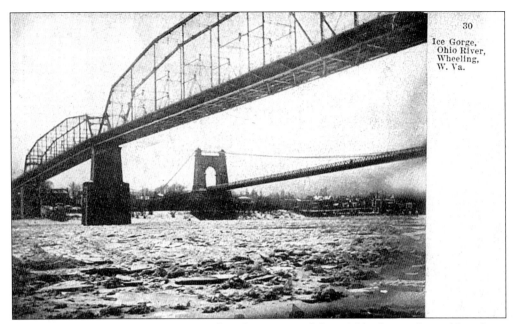

ICE GORGE, OHIO RIVER. Ice jams on the Ohio River and the neighboring creeks could, at times, became very dangerous and would have to be dynamited to allow the normal flow of the Ohio River. The Steel Bridge is on the left and the Suspension Bridge is on the right.

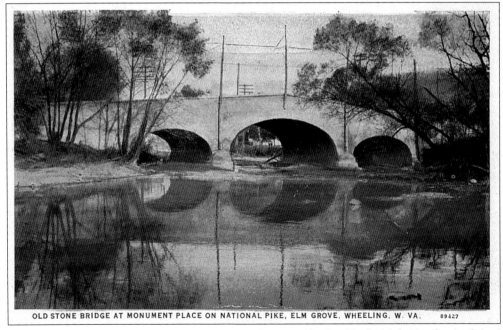

OLD STONE BRIDGE AT MONUMENT PLACE ON NATIONAL PIKE, ELM GROVE, WHEELING, W. VA. 89427

OLD STONE BRIDGE AT MONUMENT PLACE. Col. Moses Shepherd built this bridge for the federal government in 1817. It was built to carry wagon traffic over Wheeling Creek while traveling along the National Road (Rt. 40). It passed within site of the Shepherd mansion.

31

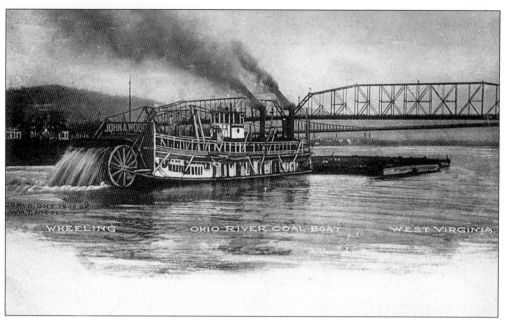

OHIO RIVER COAL BOAT. The *John A. Wood* sternwheel towboat worked on the Ohio River from 1870 to 1925. She was owned by John A. Wood and Sons, who were coal operators from Pittsburgh. The biggest coal tow until 1880, she took 21 coal boats and 8 barges of coal to New Orleans in May 1880. She was later sold to Pittsburgh Steel.

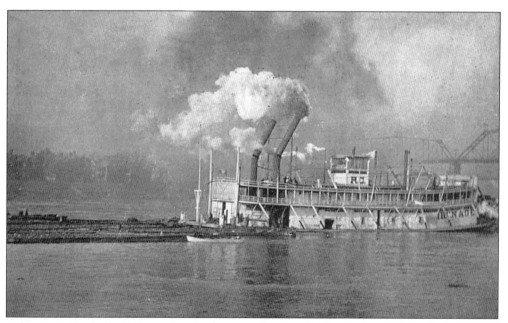

STEAMBOAT AND COAL BARGES. The bottom of the Suspension Bridge was 97 feet above the normal surface of the river. This meant that many of the steamboats could not clear because of their smokestacks. Businessmen from Pittsburgh entered a lawsuit to have the bridge raised or removed. They said that lowering the smokestacks slowed the steamers. They lost when the bridge was designated a postal route.

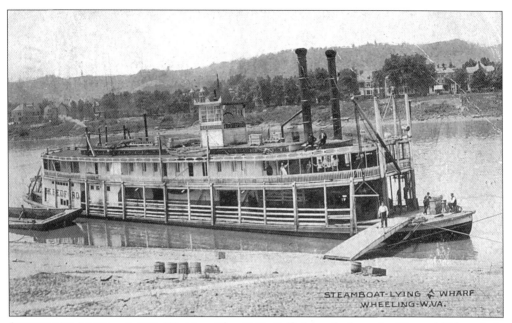

STEAMBOAT LYING AT THE WHARF. The *H.K. Bedford* was built at the Howard Shipyards in Jeffersonville, Indiana in 1885. In the fall of 1886 she was running the "low water trade" out of Wheeling. Capt. Gordon C. Greene bought her around 1890, beginning the famous Greene Line Steamers, Inc.

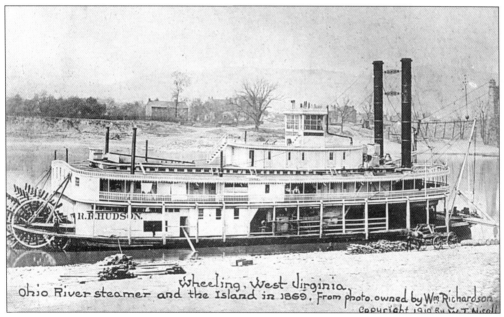

OHIO RIVER STEAMER, C. 1869. The *R.R. Hudson*'s hull was built at Murraysville, West Virginia and its steam engines and interior were completed in Wheeling in 1886. This sternwheeler ran goods and passengers from Pittsburgh to Cincinnati. On January 27, 1875 she was crushed by quickly forming ice while anchored at the Wheeling wharf.

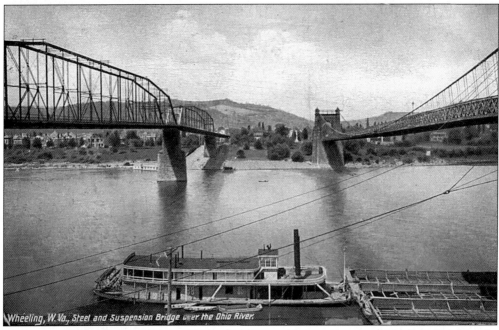

STEEL AND SUSPENSION BRIDGE, 1909. One can see the mansions on Wheeling Island in the distance. The island was called the "garden center" of Wheeling because it had many beautiful flowers and vegetable gardens. Note the guy wires to help keep the bridge from swaying in the wind.

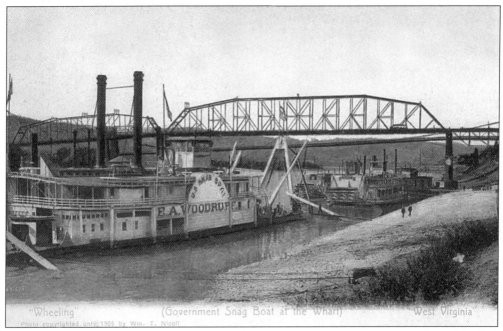

GOVERNMENT SNAG BOAT. The *E.A. Woodruff* hull was built in Covington, Kentucky and finished in Pittsburgh in 1874. Snag boats like this were used by the government to keep the waterways free of obstacles. One of the boat's first jobs was to remove the wreck of the *Pat Cleburne* in 1876.

34

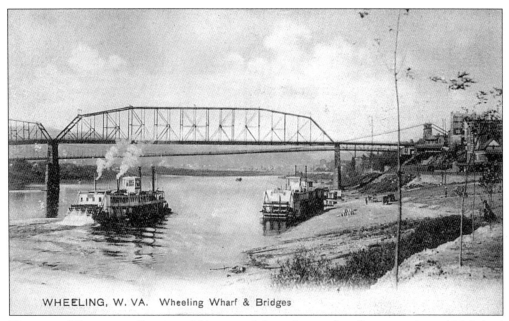

WHEELING, W. VA. Wheeling Wharf & Bridges

WHEELING WHARF AND BRIDGES. This postcard shows four modes of transportation, which helped Wheeling to grow and prosper. The bridges carried streetcars and automobiles. Steamboats landed at the wharf and to the right of the card is the Pennsylvania Railroad.

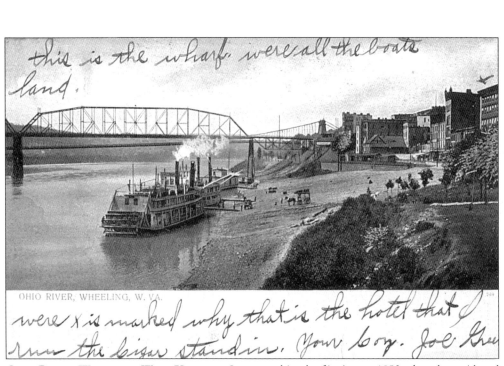

OHIO RIVER, WHEELING, W. VA.

this is the wharf. were call the boats land.

were x is marked why that is the hotel that I run the cigar stand in. Your boy. Joe Gre

OHIO RIVER, WHEELING, WEST VIRGINIA. It was on this wharf in August 1853 when the accidental ignition of a keg of gunpowder took the life of Mr. Wallaston Kimberly, a drayman unloading 29 kegs of powder. Another drayman was blinded, burnt, and blown into the river during the explosion.

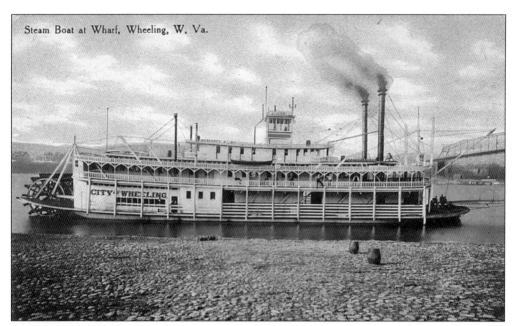

STEAMBOAT AT THE WHARF. The City of Wheeling steamboat is sitting on the West Virginia side of the Ohio River. The hull was built in Clarington, Ohio and completed in Wheeling in 1899. It made short runs out of Wheeling. It was later renamed the *Harry Lee* and sank at Brandywine Landing, 45 miles above Memphis, in 1911.

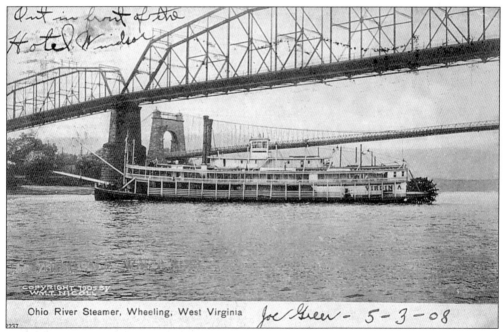

Ohio River Steamer, Wheeling, West Virginia *Joe Green - 5-3-08*

OHIO RIVER STEAMER. This is the famous sternwheeler *Virginia* as it passes under the steel bridge around 1905. She was built in Cincinnati, Ohio in 1895 and had 50 staterooms on the main decks and 10 more on the "Texas" deck. This beautiful sternwheeler was grounded in a cornfield the night of March 6, 1910.

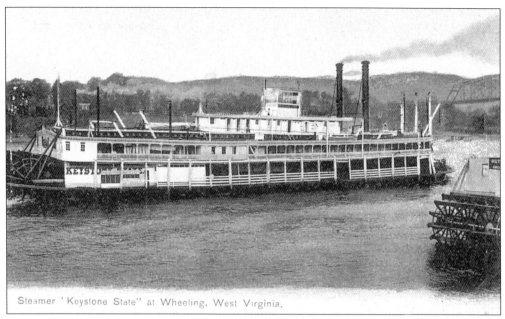

Steamer 'Keystone State" at Wheeling, West Virginia.

STEAMER *KEYSTONE STATE.* This steamer was built for the Pittsburgh and Cincinnati Packet Line. She was the "huckster" boat that left Pittsburgh every Monday. In 1913, she was sold, converted into an excursion boat, and renamed the *Majestic.* The steamer hit an intake tower in 1914 and was lost. Locals were often able to tell which steamboat was traveling on the river by the different sounds their whistles made.

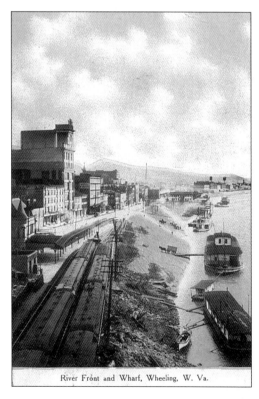

River Front and Wharf, Wheeling, W. Va.

RIVERFRONT AND WHARF, 1912. At the beginning of the 20th century there were no less than 45 regular arrivals and clearances by 13 different steamboats every week at this wharf. Three of the largest boats were the *Queen City, Virginia,* and *Keystone State.* Thousands of passengers boarded here to travel down the Ohio River on their migration to the west. Mike Fink, the famous riverman, piloted his first boat from here.

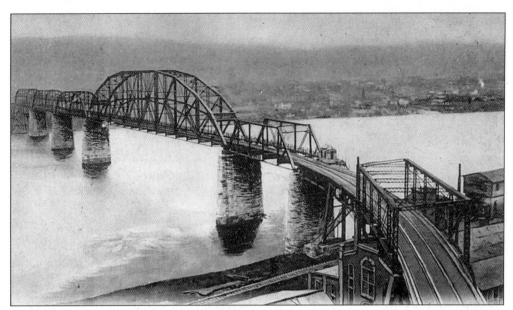

WHEELING TERMINAL RAILWAY CO. BRIDGE. Construction of this bridge began in 1888 and pedestrians were allowed to cross in September 1890. Ten-thousand people crossed on the first day. The first Wheeling & Lake Erie train crossed the bridge on August 2, 1891. The bridge was 2,097 feet long and weighed 2,000 tons. It was removed in 1993. The building underneath is the Old Top Mill, the first iron mill in Wheeling.

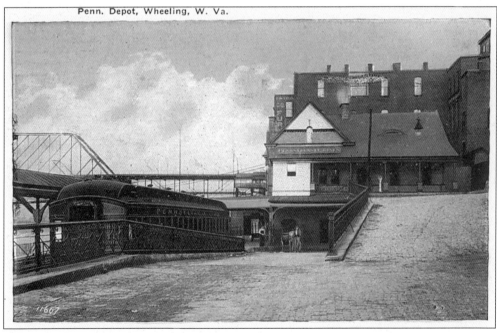

PENNSYLVANIA DEPOT. The first Pennsylvania Railroad train rolled into Wheeling on February 24, 1878. The road was then called the Pittsburgh, Cincinnati, and St. Louis Road.

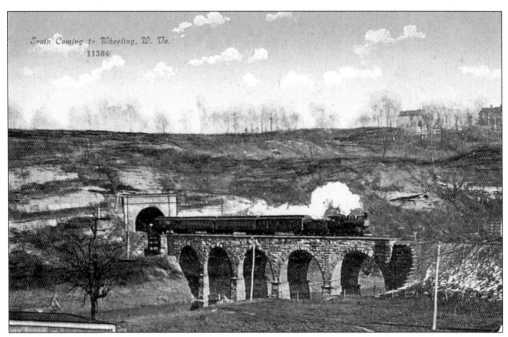

B&O BRIDGE AND TUNNEL GREEN. In 1869, the *Wheeling Intelligencer* reported three ghost sightings in or near this tunnel. According to E. Lee North's book, *Redcoats, Redskins and Red-eyed Monsters*, a reporter from a New York magazine traveled to Wheeling in 1874 to investigate the unusual sightings.

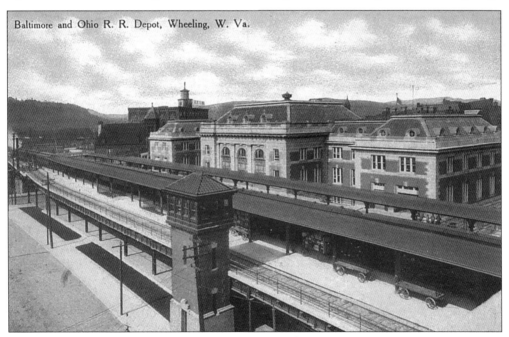

BALTIMORE AND OHIO RAILROAD DEPOT. The B&O Railroad was extended to Wheeling and the Ohio River on December 24, 1852. The first passenger station was on South Street. This depot and viaduct was completed in 1908 and at the time was the third largest in the B&O system. One hundred passenger trains came through Wheeling each day. The last passenger train left Wheeling in June 1961.

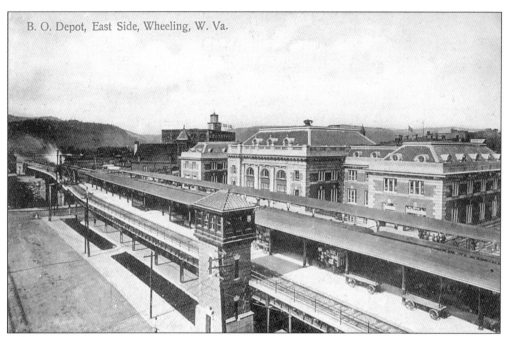

B&O DEPOT, EAST SIDE. This shows a passenger train starting to leave the station around 1910. The control tower is located at the bottom center of the card. Note the wagons loaded with freight on the platform. To the left of the control tower are staircases from the street level. The building is now owned by the state and is used by West Virginia Northern Community College.

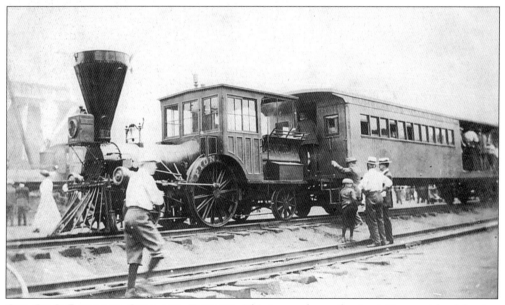

OLD B&O RAILROAD CARS AND ENGINES. This image shows the Semi-Centennial celebration held in Wheeling the week of June 15–20, 1913. The B&O Railroad Co. put on display a number of engines and cars that the company had used over the previous 50 years. The Baltimore and Ohio Railroad was the first railroad in America.

Four

GOVERNMENT AND

BUSINESS

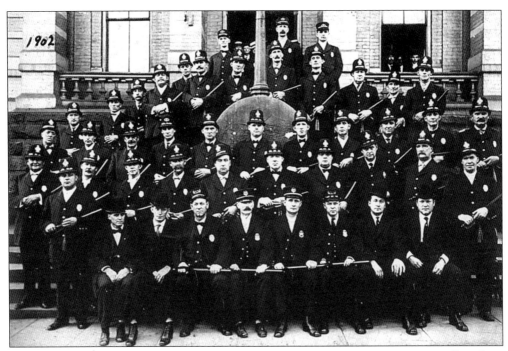

WHEELING POLICE FORCE, 1902. Since the first police officer was killed in 1868, nine officers have lost their lives in the line of duty. Six have fallen to hostile gunfire and three to traffic accidents. In this postcard notice the plethora of nightsticks, Bobby-style helmets, and thick mustaches. Stories have been told over the years about the officers' skill in using the nightsticks. Wheeling had a paddy wagon until the 1940s.

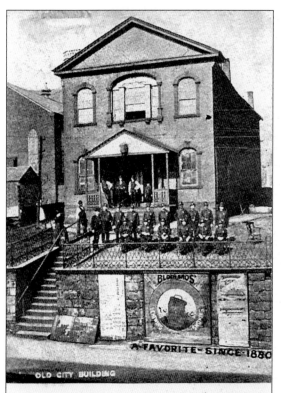

CITY BUILDING, 1875. The city purchased the Masonic Hall for $6,000 and used it as the city's headquarters for 22 years. It was nicknamed "the ark" because there were so many steps leading up to the front door. The Wheeling Pittsburgh Steel Corporation's offices are presently at this location.

OLD CITY BUILDING

Built in 1839, torn down in 1883; was located where the Schmulbach Building now stands.

OLD COUNTY JAIL. In 1836, the city assembly authorized a jail, which was built three years later. Wheeling was gaining a reputation as a sporting town and needed a jail to house the drunks, gamblers, and other lawbreakers. The building was torn down in 1904.

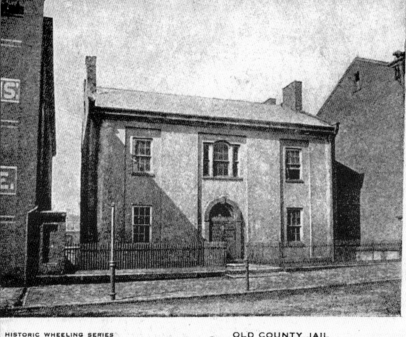

Built in 1839, torn down in 1904. Was located where Virginia Theatre now stands. Wheeling, W. Va.

HISTORIC WHEELING SERIES OLD COUNTY JAIL

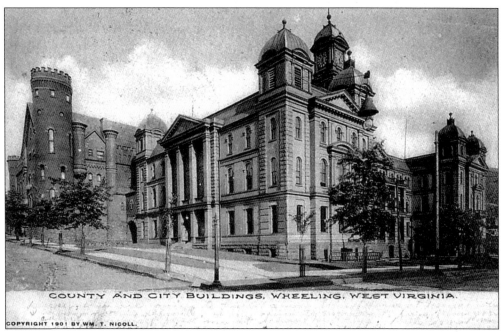

COUNTY AND CITY BUILDINGS, WHEELING, WEST VIRGINIA.

COPYRIGHT 1901 BY WM. T. NICOLL.

OLD CITY AND COUNTY BUILDING. Originally built by the city in 1876 at a cost of $120,000, this structure was used as a state capital building until 1885. In 1934, an employee who tendered the furnace was found guilty of killing a man in the basement of this building. He didn't have far to go to serve out his life sentence since the jail is the turret-type building to the left.

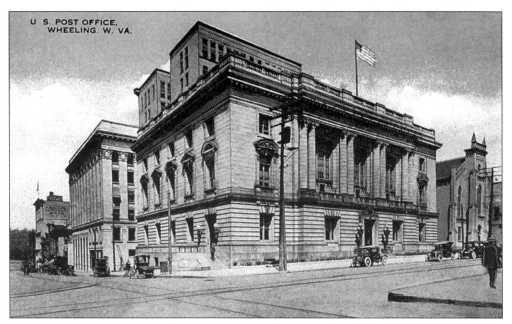

U S. POST OFFICE, WHEELING. W. VA.

UNITED STATES POST OFFICE. The post office was built on the site of the Oglebay mansion. Construction was going on at the same time that the Schmulbach Building was going up behind it. It was occupied in 1909 and used as the main post office until a new facility was built in 1966. The courtrooms are still in use today.

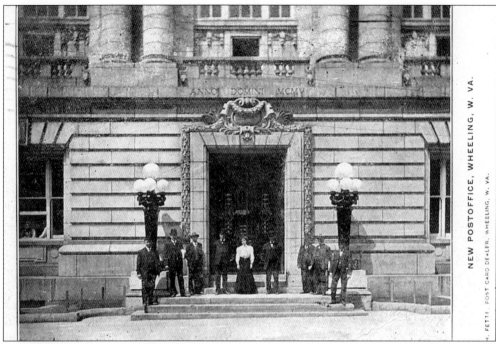

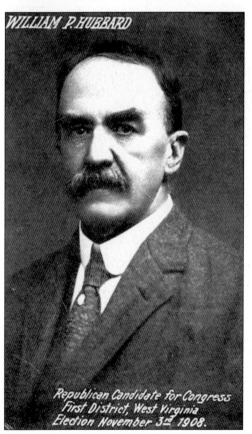

WILLIAM P. HUBBARD

Republican Candidate for Congress
First District, West Virginia
Election November 3rd 1908.

UNITED STATES POST OFFICE AND COURTHOUSE. In 1948, "Big Bill" Lias, a local gambler and racetrack owner, was charged with income tax evasion and brought to this court. He entered through those doors to attend his numerous hearings. He beat the evasion charge but still owed $3 million in back taxes and lost the race track to settle what he owed. The I.R.S. then sold the track to the infamous Purple Gang of Detroit.

WILLIAM P. HUBBARD, 1843–1921. Mr. Hubbard was a prominent Wheeling lawyer and politician. He was a veteran, having fought for the Union in the Civil War as a member of the Third West Virginia Cavalry. This Republican was elected to the 60th and 61st United States Congresses, March 1907–1911.

44

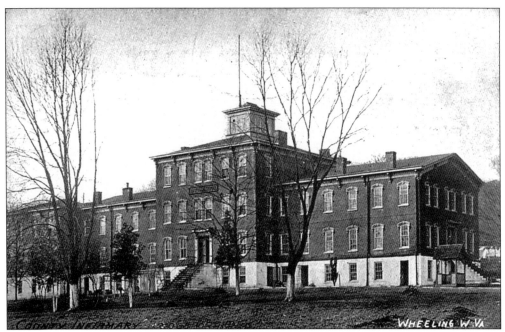

County Infirmary. The infirmary was used for the housing and care of tuberculosis patients. The patients were later moved to the former mansion of Mr. Schmulbach at Rooney's Point. The structure on this postcard was then used as the first Bridge Street school. A new school was completed in 1924 on the same spot.

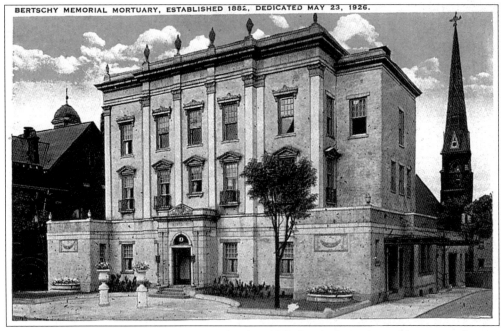

BERTSCHY MEMORIAL MORTUARY, ESTABLISHED 1882, DEDICATED MAY 23, 1926.

Bertschy Memorial Mortuary. Completed in 1859 for Linsly Institute, this structure became West Virginia's first capital building on June 20, 1863 and served in that capacity until 1870. Later it was purchased by Mr. Bertschy for his funeral home, and today it is an office building.

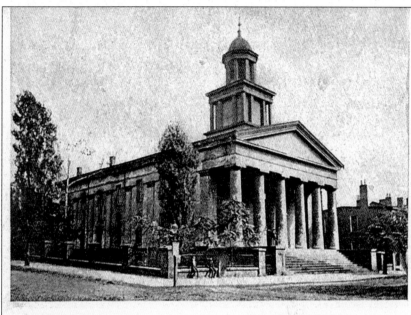

Built in 1839, torn down in 1902. Was located at corner of Monroe and Twelfth streets, now Twelfth and Chapline streets, Wheeling, W. Va.

HISTORIC WHEELING SERIES OLD COURT HOUSE

OLD COURTHOUSE. On March 17, 1836, the city assembly authorized the location of the site for the courthouse of Ohio County, Virginia. It purchased two lots at the corner of 12th and Chapline Streets for a new courthouse and jail. Built in 1839, it remained the official courthouse until 1885. It was razed in 1902.

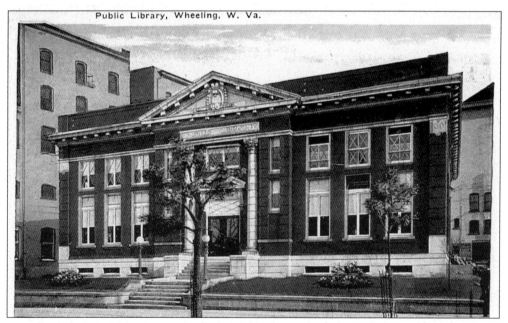

Public Library, Wheeling, W. Va.

PUBLIC LIBRARY. Andrew Carnegie donated money to build over 2,800 libraries around the world and offered to build one on this spot. However, local labor unions, still furious with Carnegie over his role in the 1892 Homestead Strike, made sure his generous offer was refused by the citizens of Wheeling. The community constructed this library and opened it on January 11, 1911.

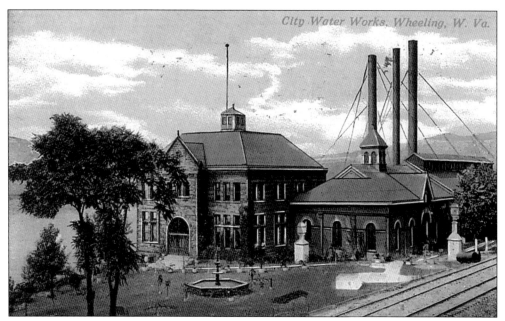

CITY WATER WORKS. This location was abandoned by the city when the new water works opened in Warwood during 1925. It was bought by Wheeling Machine Products around 1926 to make detonator tubes for bombs. On June 8, 1941 the plant caught fire and most of the machinery was destroyed. The owner always believed that it was an act of saboteurs. The building is now owned by Mull Machine.

PARSHALL DAIRY. This well-known East Wheeling dairy was located on 16th Street from 1901 to 1921, when owner Harry Parshall died. Mr. Parshall is standing in the doorway with his overcoat and favorite pug-ugly hat. This innovative dairyman owned a patent for a cooling machine, which he used in the processing of milk. The Parshalls have traced their family tree back to Rollo the Viking.

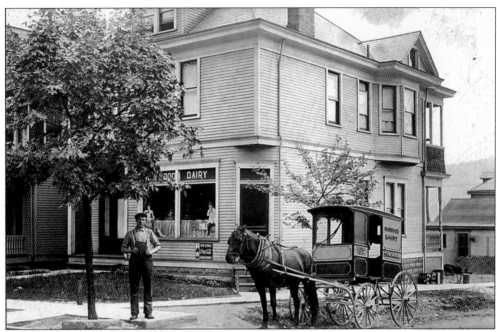

WARWOOD DAIRY. Mr. A.H. Pape's dairy stood at 1815 Warwood Avenue and began operation in 1912. He used this horse-drawn wagon to make his daily milk and ice cream deliveries. The building to the rear of the dairy was built at the beginning of the 20th century to house Warwood's first fire department. The building was called the "hose house" and was used for a while as the town hall.

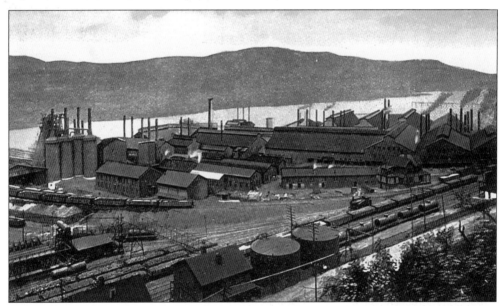

NATIONAL TUBE WORKS. A pipe mill was built here in 1877 under the leadership of Wheeling resident Francis J. Hearne. It was in this mill that steel was butt-welded into pipe for the first time in history. Until then pipe was made out of iron. After a violent strike, United States Steel Corporation demolished most of the facility except for the blast furnace, which it sold to Wheeling Steel Corporation.

WHEELING STEEL CORPORATION. This building was originally constructed for local beer-baron Henry Schmulbach in 1905. Wheeling Steel was formed in 1920 and purchased this building in 1921 for their corporation headquarters. Until the 1960s there were bronze spittoons on each floor. Shortly after its formation this steel company had 28,000 employees in two states.

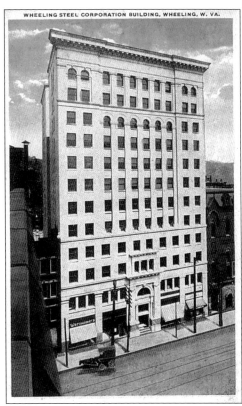

WHEELING STEEL CORPORATION BUILDING, WHEELING, W. VA.

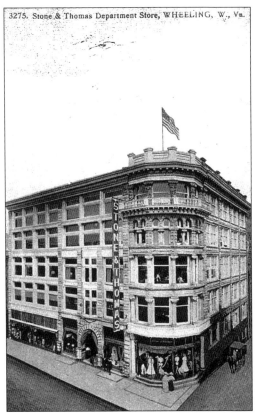

3275. Stone & Thomas Department Store, WHEELING, W., Va.

STONE AND THOMAS DEPARTMENT STORE. In 1847, this Wheeling landmark opened and developed into a major department store with 20 stores in four states. It was founded by brothers-in-law Elijah J. Stone and Jacob C. Thomas. Mr. Stone was a religious man and asked his employees to attend church regularly. This store was sold in 1998 and closed two years later.

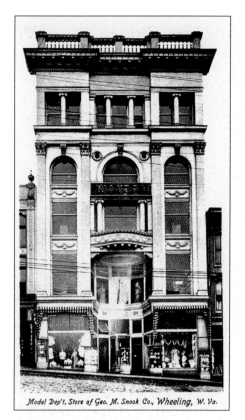

Model Dep't. Store of Geo. M. Snook Co., Wheeling, W. Va.

DEPARTMENT STORE OF GEORGE M. SNOOK CO. In 1884, George M. Snook, G. Rentsch, and Albert Wilkie founded this business. The building was constructed at 1110–1114 Main Street as a wholesale and retail dry goods department store at the turn of the century. At one time the firm had 150 employees. Mr. Snook and family lived in a palatial home in Pleasant Valley.

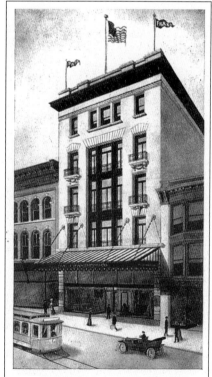

H. C. FRANZHEIM CO.'S NEW BUILDING,
1126-1128-1130 MAIN STREET, WHEELING, W. VA,
"EVERYTHING FOR HOUSEKEEPING"

H.C. FRANZHEIM CO.'S NEW BUILDING. This building was opened for business on April 11, 1910 at 1126–1130 Main Street. The company advertised that they carried everything needed for housekeeping. For the opening two days the Meister's Orchestra entertained the public as they entered the store. An estimated crowd of 2,000 people visited on the opening day.

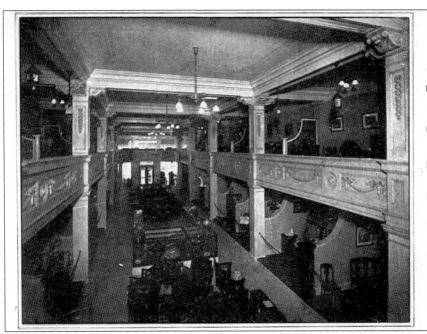

Interior View First Floor—Rear to Front

H. C. FRANZHEIM CO.

EVERYTHING FOR HOUSEKEEPING

WHEELING, W. VA.

1126-1128-1130 Main Street

H.C. FRANZHEIM CO. INTERIOR. The *Wheeling Intelligencer* reporter that viewed the store on opening day described the interior as a "a modern Aladdin's palace." It had five floors of furniture and house furnishings.

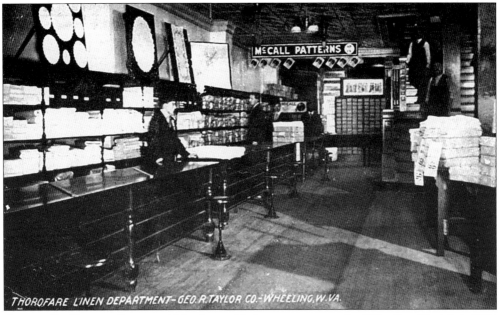

GEORGE R. TAYLOR COMPANY. Mr. George Taylor came to a growing Wheeling, Virginia in 1844 and became a member of the Maul & Taylor dry goods firm. Mr. Taylor purchased his partner's interest in 1861 and the firm continued to grow. By 1890, it was the largest dry goods store in West Virginia. It was located at 1156 Main Street. The name was changed to Stifel and Taylor Corporation in 1956.

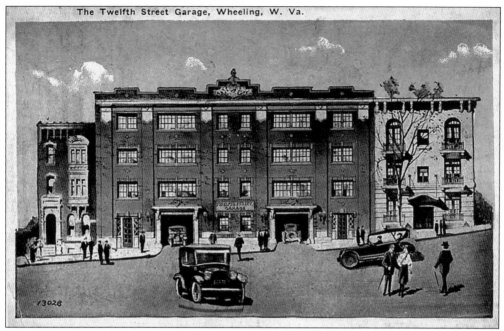

The Twelfth Street Garage, Wheeling, W. Va.

TWELFTH STREET GARAGE. When the garage was built in 1922 its location across the street from the Virginia and Court theatres was ideal. The Unitarian Church was razed in 1930 to allow the garage to expand. The racketeer "Big Bill" Lias parked his 11 cars and trucks here in the 1930s. This was when he was the "Numbers Kingpin" of the valley. The garage took good care of all those vehicles.

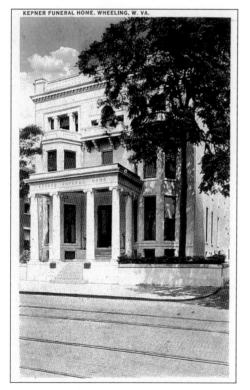

KEPNER FUNERAL HOME, WHEELING, W. VA.

KEPNER FUNERAL HOME. This building was constructed at 1308 Chapline Street as a private residence around 1840. Lydia Speidel changed the appearance of the house in the 1880s. Today it is owned by the Kepner Funeral Home, which has served the area since 1845.

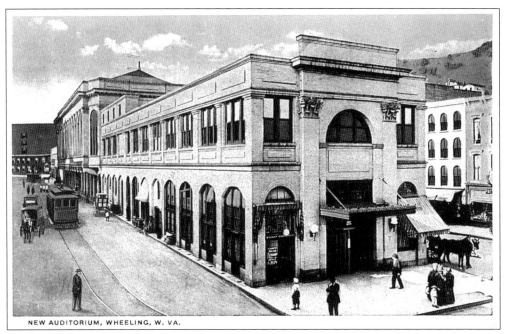

NEW AUDITORIUM, WHEELING, W. VA.

NEW AUDITORIUM. A market house and auditorium was finally built after many years of discussion when the Board of Trade backed the project. The old wooden structure was replaced in 1913 with this steel-framed facility. It was the longest building in the state when it was constructed. The auditorium was leveled in 1964 to make way for a market plaza, or a pedestrian mall.

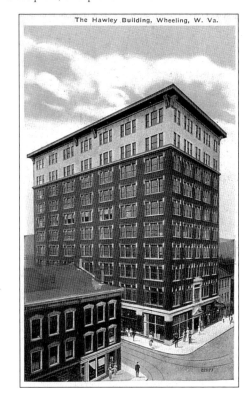

The Hawley Building, Wheeling, W. Va.

HAWLEY BUILDING. Named after its owner, multi-millionaire James L. Hawley, this building was constructed around 1912 only a few yards from where Fort Henry was built in 1774. WWVA Radio had its first studios in this building. Saturday night Jamboree shows also started here on January 7, 1933. Mull Industries now owns the building.

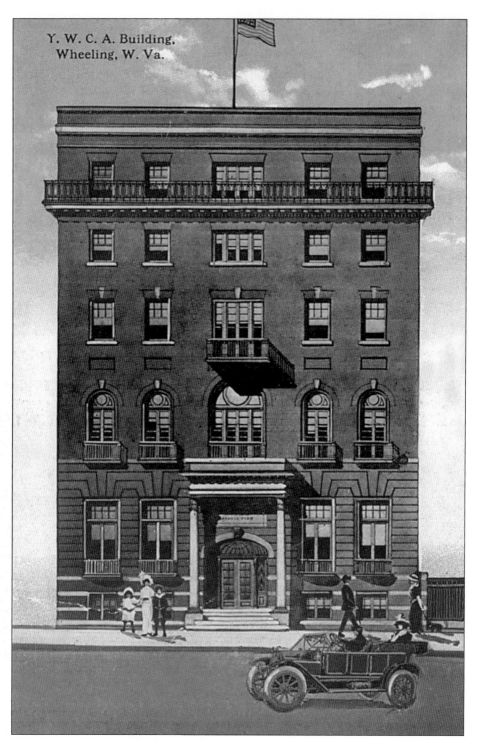

Y. W. C. A. Building,
Wheeling, W. Va.

YWCA BUILDING. The YWCA was chartered on April 6, 1906 at 1030 Main Street. Two years later, it moved to the building at 1207 Chapline Street. The present structure at 1100 Chapline Street, shown on this postcard, was erected in 1915. The pool opened on March 1, 1916.

Five

FLOODS AND FIRES

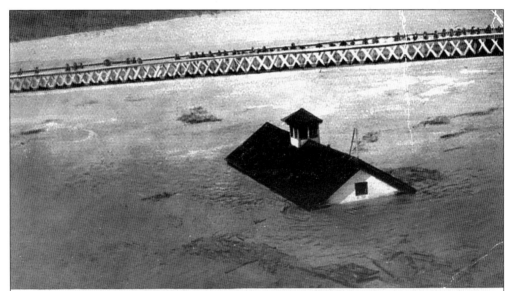

School House afloat on the Ohio River, Flood of March, 1907, Passing under the Bridge at Wheeling, W. Va. (This School Building floated from Warrenton, Ohio, to Sistersville, W. Va., a distance of over 100 miles.)

FLOATING SCHOOLHOUSE. Although Thomas Jefferson called the Ohio River "the most beautiful river on earth," it could at times turn ugly as in the March 1907 flood. Wheeling citizens, as well as thousands down river, watched in horror from the riverbanks and bridges as houses, carriages, and even livestock floated by. This school building is shown as it passed under the Suspension Bridge. It traveled over 100 miles.

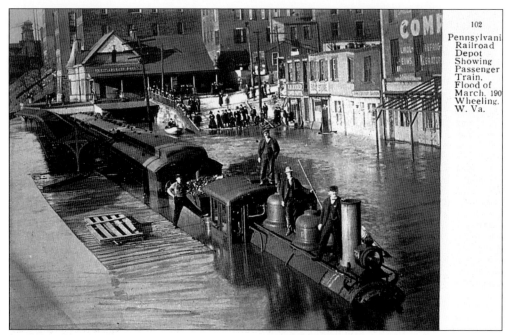

102
Pennsylvani
Railroad
Depot
Showing
Passenger
Train.
Flood of
March. 190
Wheeling.
W. Va.

MARCH 1907 FLOOD. This was one of the worst floods to hit Wheeling. Reaching a height of 50.1 feet, it caused a number of deaths by drowning and by fire. This passenger train was caught at the station in the fast rising waters and could not move. The passengers onboard were removed and put up in local hotels until the flood receded and a new train was brought in.

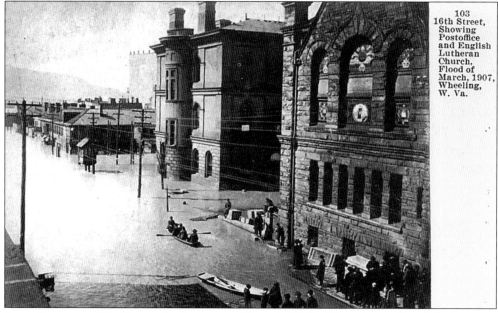

103
16th Street,
Showing
Postoffice
and English
Lutheran
Church,
Flood of
March, 1907,
Wheeling,
W. Va.

POST OFFICE IN 1907 FLOOD. Both the post office and the English Lutheran Church had water in the basement and had to suspend operations until the water receded. Then began the long process of cleaning the debris left by the flood.

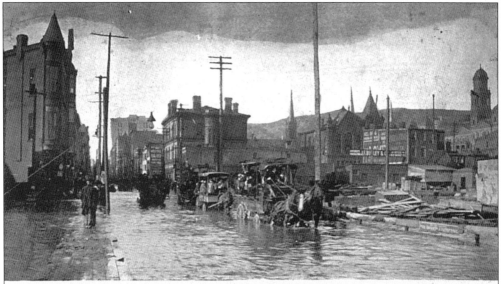

112. Market Street, looking North from Seventeenth Street, Flood of March, 1907, Wheeling, W. Va.

MARKET STREET FROM 17TH STREET, 1907 FLOOD. Many people living to the south of Wheeling Creek were trapped without provisions due to the speed of this flood. Wagons to move belongings, such as these, were at a premium. Some families lost everything they owned.

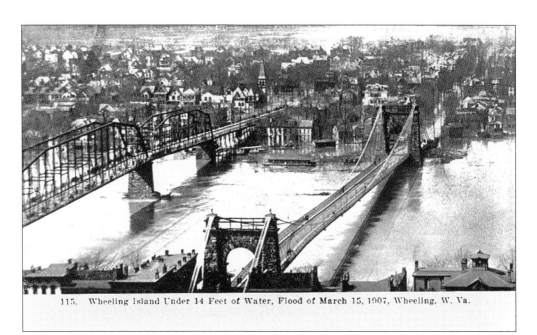

115. Wheeling Island Under 14 Feet of Water, Flood of March 15, 1907, Wheeling, W. Va.

WHEELING ISLAND, 1907 FLOOD. When this flood crested at 50.1 feet, it was 14.1 feet over the flood stage. The island was completely covered. News articles at the time reported that the flood had left only a few buildings undamaged. Many outhouses and shanties from up river were deposited on the island.

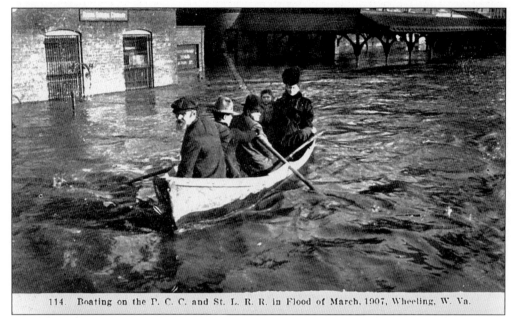

114. Boating on the P. C. C. and St. L. R. R. in Flood of March, 1907, Wheeling, W. Va.

ROWBOAT, 1907 FLOOD. These people are rowing against the current away from the train station. The woman in the fur coat and large hat looks slightly overdressed for the occasion. She may have been forced to choose only one outfit to save from the flood and of course chose her best coat. She may have also been out for a boat ride just to see the flood.

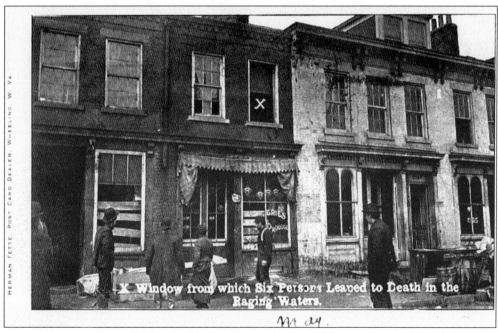

X Window from which Six Persons Leaped to Death in the Raging Waters.

"X" MARKS THE SPOT. During the March 1907 flood some buildings caught fire behind this house at 2156 Main Street. Six people died by jumping out of the window with the X mark and into the raging waters.

58

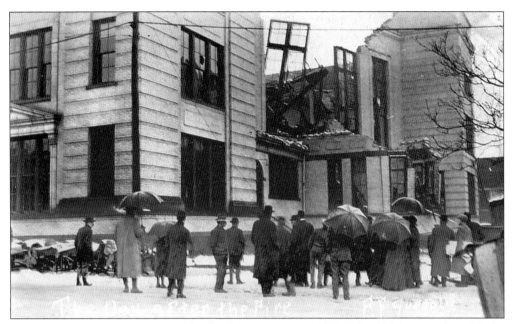

WHEELING HIGH SCHOOL FIRE. The fire department was criticized for their late reaction after the school caught fire on January 3, 1914. Three lives were lost in the blaze. The fire department's alarm system completely failed. Also contributing to the delay was the fact that the closest fire squad was out exercising their horses.

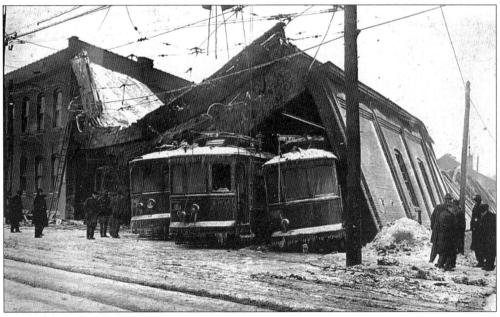

WHEELING CAR BARN FIRE. On February 3, 1918 a fire destroyed 29 streetcars and the main section of the Wheeling Traction Company storage barn. The $300,000 loss from this fire would be in the millions today. It was one of the last fires in the city answered with horse-drawn steam-fired engines. Two of the horses were named Bob and Frank. They were known as the White Team from the Chemical Company.

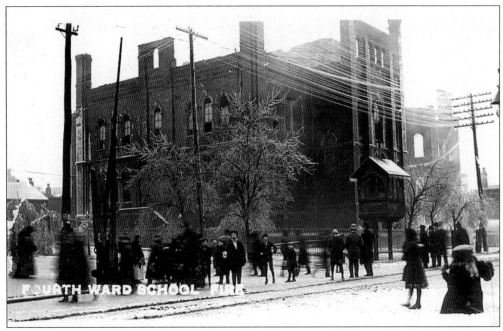

FOURTH WARD SCHOOL FIRE. Union School was damaged to the extent of $50,000 in a fire which broke-out the morning of February 3, 1908, after the children had entered the school for morning classes. Students attempted to fight the fire before the alarm sounded. No students were hurt.

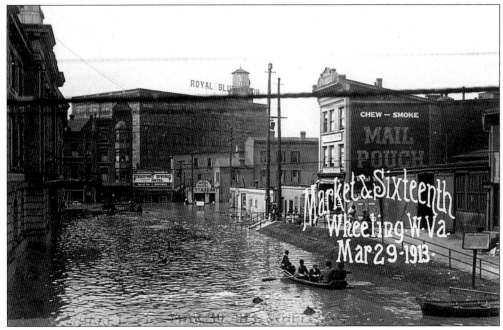

MARKET AND 16TH STREET, MARCH 29, 1913. The raging Ohio River reached 51.1 feet on March 28. That was 15.1 feet over the flood stage. The B&O Railroad station is on the left. Note the mail pouch sign on the building. The people in the boat are inspecting the damage.

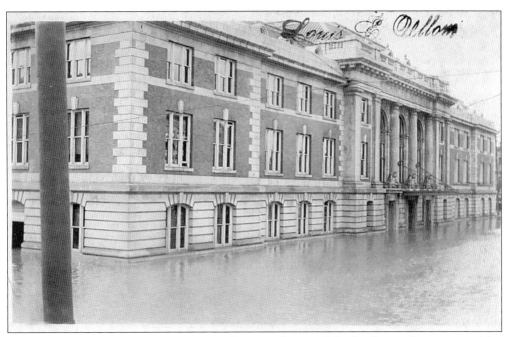

B&O Railroad Station, 1913 Flood. The water devastated the first floor and passenger waiting rooms at the railroad. At one point during the flood a white coffin floated down the river and was swept away before it could be ascertained whether it contained a corpse. During a later flood in 1936 employees of the railroad toured the inside of the building in a rowboat.

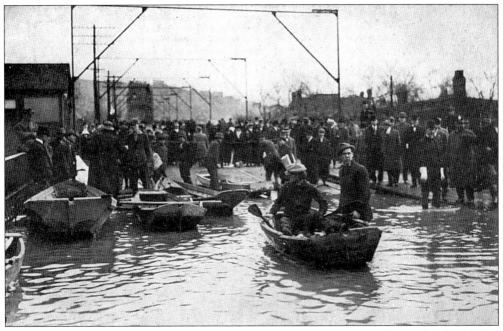

Steel Bridge, 1913 Flood. Every boat for miles around was put to use during the flood. They were used for rescue and for delivering supplies. This postcard was taken at the west end of the Steel Bridge.

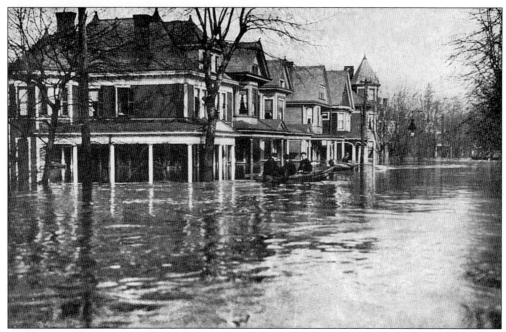

HOMES ON WHEELING ISLAND, 1913. The water climbed half-way up the first floor in these houses. Twenty thousand people were driven from their homes in various sections of Wheeling. Many schools, churches, and organizations opened their doors to refugees and offered food and shelter.

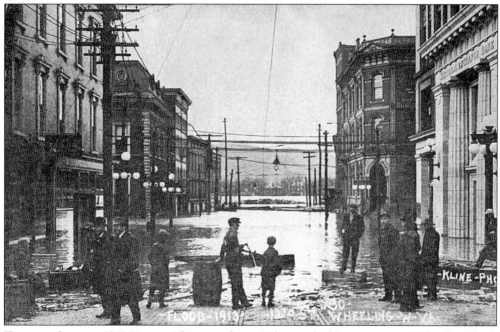

TWELFTH STREET, 1913 FLOOD. This scene shows 12th street looking west toward Wheeling Island. The National Exchange Bank and the People's Bank are on the right. Note the pile of debris floating down the river. Those are mansions in the distance.

Six

HOSPITALS AND CHURCHES

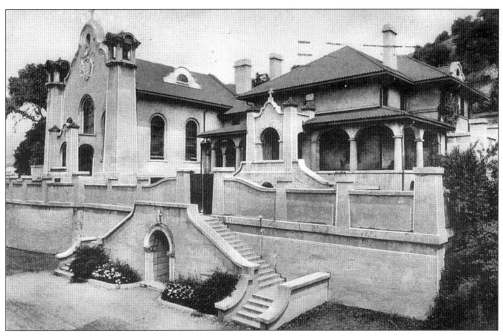

CARMELITE MONASTERY. This Spanish mission–style monastery was built in Woodsdale between 1913 and 1915. The Carmelite nuns were a contemplative order who served God by obedience and prayer. Walls completely surrounded the 2.5-acre site. The Carmelites vacated the premises in 1975. It is now privately owned.

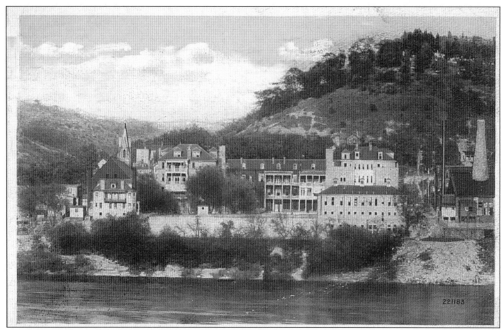

WHEELING HOSPITAL. The Wheeling Hospital was located in North Wheeling from 1856 to 1975. During the Civil War it was a United States Army General Military Hospital. Soldiers from both the North and the South often lay side by side. The hospital was later designated as a Marine Hospital, and boats on the Ohio River would often salute their sick comrades as they passed.

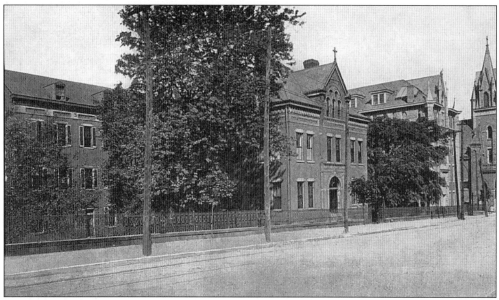

WHEELING HOSPITAL AND SACRED HEART CHURCH. The hospital was founded in 1850 by Dr. Simon P. Hullihen, the "Father of Oral Surgery," and Bishop Richard V. Whelan. From 1853 to 1856 it was located at 15th Street, and it then moved to the 50-bed Michael Sweeney mansion in North Wheeling, overlooking the Ohio River. The mansion, demolished around 1929, is in the middle of the postcard.

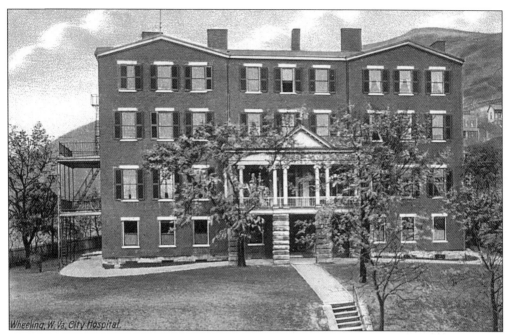

Wheeling, W. Va. City Hospital.

CITY HOSPITAL. This building was constructed around 1850 for the Wheeling Female Seminary. In 1891, the newly formed City Hospital purchased the facility. Shortly thereafter the building was razed to make room for a new structure. The name was later changed to Ohio Valley General Hospital.

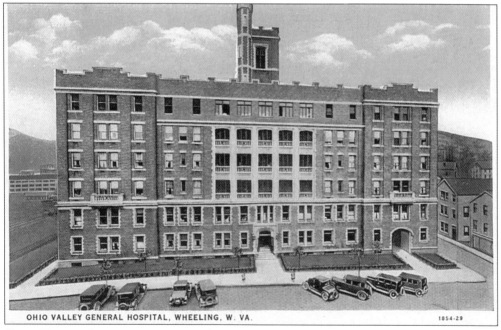

OHIO VALLEY GENERAL HOSPITAL, WHEELING, W. VA. 1854-29

OHIO VALLEY GENERAL HOSPITAL. This $300,000 building was constructed between 1912 and 1913 on the same site as the old City Hospital. It opened on January 17, 1914 and had a 154-person, in-patient capacity. Between 1927 and 1929 the hospital had again outgrown its capacity and was enlarged to provide an additional 100 beds.

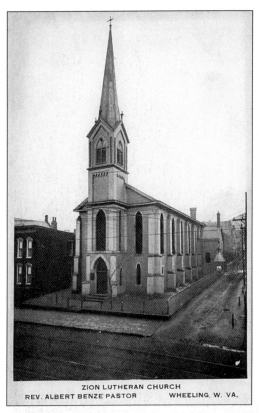

ZION LUTHERAN CHURCH
REV. ALBERT BENZE PASTOR WHEELING, W. VA,

ZION LUTHERAN CHURCH. The Zion Lutheran Church was founded in May 1850. On May 21, 1862 a killer tornado struck Wheeling, leveling the building and killing 3 children and injuring 10 others. The church was rebuilt and remained there until 1966 when the congregation moved to Bethlehem, West Virginia. It is now the site of the Towngate Theatre. Some say it is haunted.

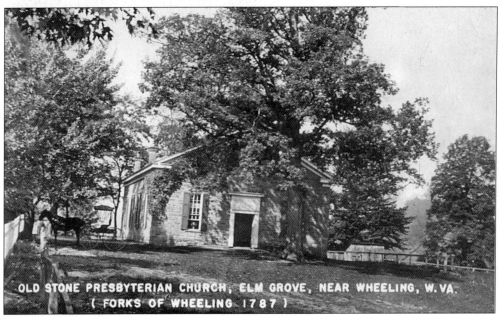

OLD STONE PRESBYTERIAN CHURCH, ELM GROVE, NEAR WHEELING, W. VA.
(FORKS OF WHEELING 1787)

OLD STONE PRESBYTERIAN CHURCH. This church was built in 1790 in the Old Stone Church Cemetery in Elm Grove, West Virginia. It was torn down in 1913 and the stone was used for the foundations of new homes. This congregation was formed in 1787 and is one of the oldest in the area.

ST. JOHN'S GERMAN LUTHERAN CHURCH.
The church was organized in 1836 for the
growing number of German immigrants coming
to Wheeling. It was originally located on 18th
Street and then at the corner of 17th and Market
Streets. This beautiful structure was completed in
1906 on 22nd Street at a cost of $74,000.

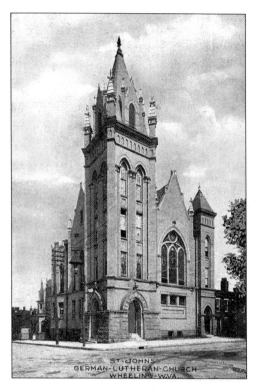

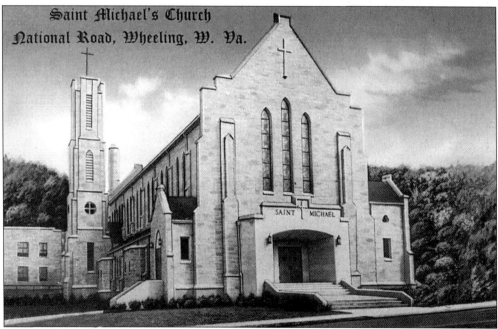

ST. MICHAEL'S CHURCH. Founded as a parish in 1897 by Rev. Patrick J. Donahue, the parishioners' first church was built on Edgington Lane the same year with 25 families in the congregation. In 1951, this new church of modified English Gothic design was completed at Seibert Avenue and National Road.

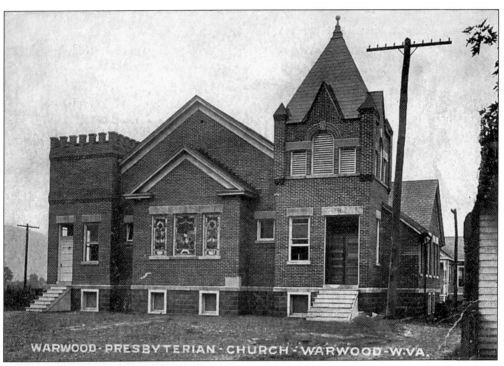

WARWOOD-PRESBYTERIAN-CHURCH-WARWOOD-W.VA.

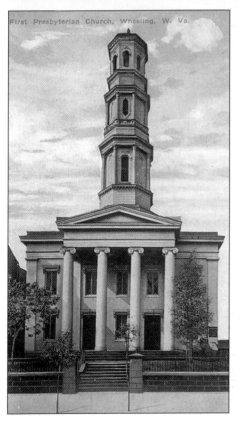

First Presbyterian Church, Wheeling, W. Va.

WARWOOD PRESBYTERIAN CHURCH. This church was organized on January 18, 1906 in Glenn's Run School House with 22 charter members. It was called the Richland Presbyterian Church until 1924. This building on 20th Street was dedicated on October 4, 1908. Rev. J.P. Stoops was the first pastor. A new church was constructed in 1956 on North 23rd Street.

FIRST PRESBYTERIAN CHURCH. The oldest structure in downtown Wheeling, this Greek Revival building on the west side of Chapline Street was erected in 1825. It features a pedimented portico with Ionic columns. The tower, added in 1836, was dismantled around 1900.

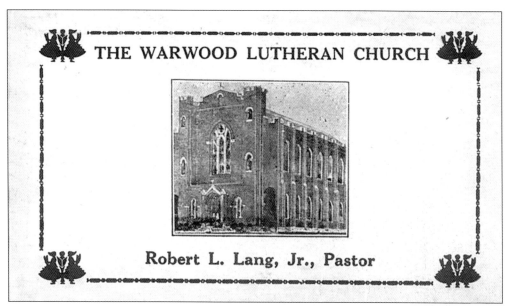

THE WARWOOD LUTHERAN CHURCH

Robert L. Lang, Jr., Pastor

WARWOOD LUTHERAN CHURCH. The Lutherans formed a church in 1912 and the building was completed in 1918. This was the home church of the famed opera star Eleanor Steber. It is now the office of Thomas Ream, M.D. who as a young boy attended this church. His mother was the Sunday School piano player.

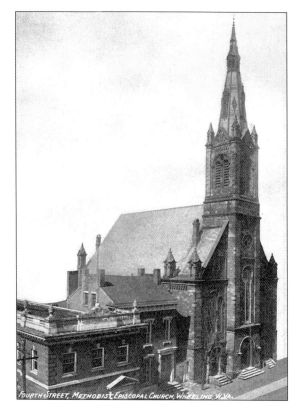

FOURTH STREET METHODIST EPISCOPAL CHURCH. The world renowned singer Jennie Lind performed here in 1851. This church was dedicated on February 24, 1836, the same year Wheeling was incorporated as a city. Damage to this building occurred during the erection of an adjacent business and the church had to be demolished.

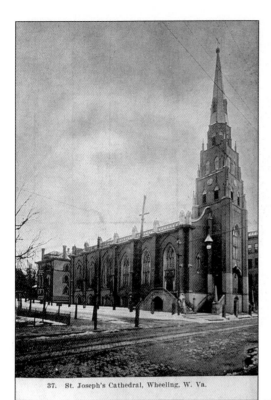

37. St. Joseph's Cathedral, Wheeling, W. Va.

ST. JOSEPH'S CATHEDRAL. The first church on this site was St. James Church, constructed in 1847–1848. When Wheeling became a diocese in 1850, St. James became a cathedral. It was renamed St. Joseph's Cathedral in 1872. A small fire in the early 1920s caused structural damage and it was razed. This Edward Weber building was dedicated in 1926.

JEWISH TEMPLE, EOFF STREET. This congregation was founded in 1849, the same year that the Suspension Bridge was built. For a number of years this small group met in private homes and lofts until they were able to raise enough funds to construct this $20,000 temple. It opened in April 1892 on Eoff Street and south of Twelfth Street. In 1958, a new temple was opened on Bethany Pike.

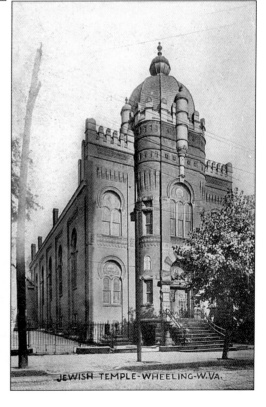

JEWISH TEMPLE-WHEELING-W.VA.

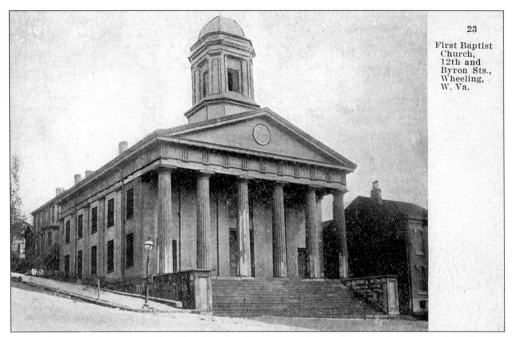

First Baptist
Church,
12th and
Byron Sts.,
Wheeling,
W. Va.

FIRST BAPTIST CHURCH. The First Baptist Church at 12th and Byron Streets was built by the Episcopalians in 1837. They remained at this spot until 1966 when the First Baptist congregation purchased the land. Few people know it but a former pastor is buried under the front steps. The Rev. William Armstrong was buried there with full ceremonies over 100 years ago.

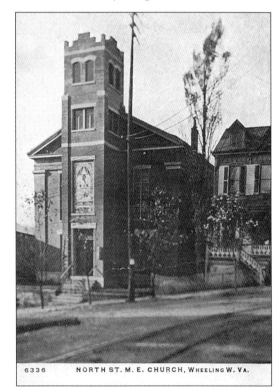

6336 NORTH ST. M. E. CHURCH, WHEELING W. VA.

NORTH STREET METHODIST CHURCH. This church was organized in 1849 under the direction of Rev. Frank De Hass. At the time of its organization, it was a unit of the Methodist Episcopal Church. In 1839, it became part of the Methodist Church and in 1968 it changed again to become part of the United Methodist Church. An abandoned baby was left in the lobby in March 1915.

71

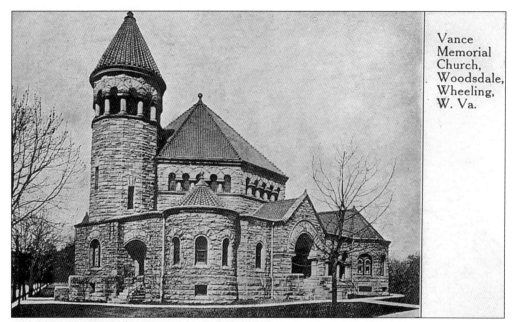

Vance Memorial Church, Woodsdale, Wheeling, W. Va.

VANCE MEMORIAL CHURCH. This Presbyterian church was organized and a Richardsonian Romanesque chapel was dedicated on June 27, 1897. James Nelson Vance, a local steel baron, founded the church in honor of his parents James and Mary Vance. Mr. Vance had bought the land and donated the money to build the church.

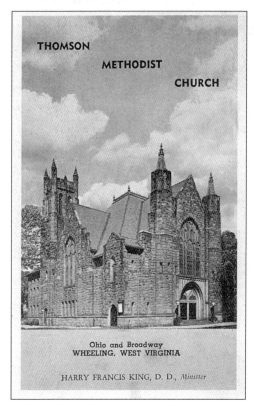

THOMSON METHODIST CHURCH

Ohio and Broadway
WHEELING, WEST VIRGINIA

HARRY FRANCIS KING, D. D., *Minister*

THOMSON METHODIST CHURCH. The Thomson Methodist Church was organized in 1866. The first church edifice was erected on Broadway Street. In 1912, following a Billy Sunday revival, 264 new members joined the church, an increase of 50%. A new church was built between 1913 and 1915. The church was named in honor of Bishop Thomson, who died while visiting Wheeling.

ST. MATTHEWS CHURCH. The first parish meeting at St. Matthews Church was held on May 11, 1819. The first rector was Rev. John Armstrong, who came here for the sum of $100 per year. This is the fourth structure built for this congregation. It is located at 1410 Chapline Street and was completed in July 1871.

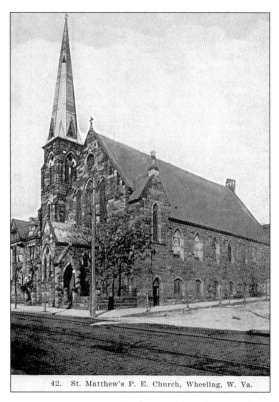

42. St. Matthew's P. E. Church, Wheeling, W. Va.

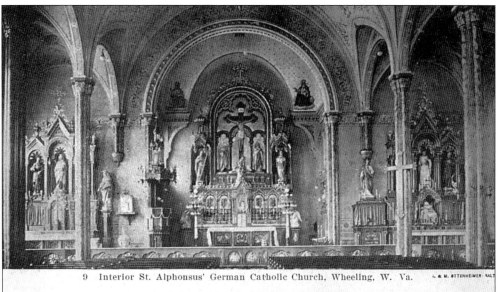

9 Interior St. Alphonsus' German Catholic Church, Wheeling, W. Va.

INTERIOR OF THE ST. ALPHONSUS GERMAN CATHOLIC CHURCH. This structure was designed by German-born pastor Anthony Schuemann, a Capuchin priest. The stained-glass windows were imported from Innsbruck, Austria, in 1905. The statue to the Holy Trinity just inside the front door is very rare. This parish at one time had an orphanage and a grade school. The Capuchin friars served this church for 111 years.

"Billy" Sunday Tabernacle Under Construction, 1st Day. Wheeling, W. Va.

C. F. RENNARD, PHOTO., WHG

BILLY SUNDAY TABERNACLE UNDER CONSTRUCTION, FIRST DAY. The former major league baseball player Billy Sunday was an innovator of the most dramatic evangelical type of religious service. Special facilities had to be built to hold the burgeoning crowds when Billy Sunday came to Wheeling in January 1912.

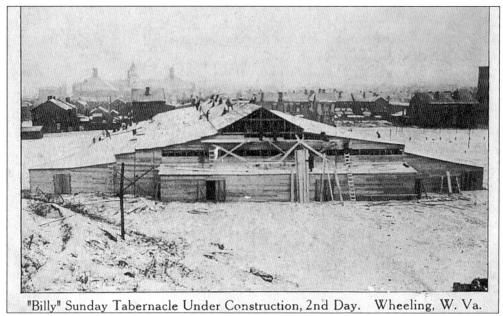

"Billy" Sunday Tabernacle Under Construction, 2nd Day. Wheeling, W. Va.

BILLY SUNDAY TABERNACLE UNDER CONSTRUCTION, SECOND DAY. The site chosen for this revival was the east end of 26th Street, later the location of a city playground. Local businesses contributed money, supplies, wiring, and cut nails for the project. The number of volunteers was estimated at over 500.

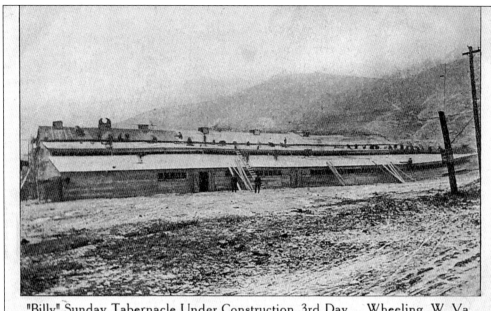

"Billy" Sunday Tabernacle Under Construction, 3rd Day. Wheeling, W. Va.

C. F. RENNARD, PHOTO., WHG.

BILLY SUNDAY TABERNACLE UNDER CONSTRUCTION, THIRD DAY. Even the large cities were unable to provide adequate auditoriums of sufficient capacity and had to build facilities such as this.

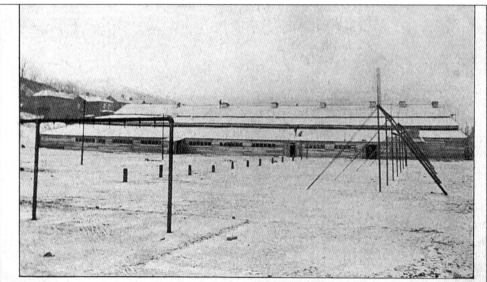

"Billy" Sunday Tabernacle Completed, 4th Day, Feb. 3rd, 1912. Wheeling, W. Va.

C. F. RENNARD, PHOTO., WHG

BILLY SUNDAY TABERNACLE UNDER CONSTRUCTION, FOURTH DAY. This huge tabernacle was completed on the fourth day by church volunteers from throughout the Ohio Valley. Twenty thousand people heard the opening day of "revival" with townspeople arriving by horse-and-buggy, early automobiles, and specially chartered trains.

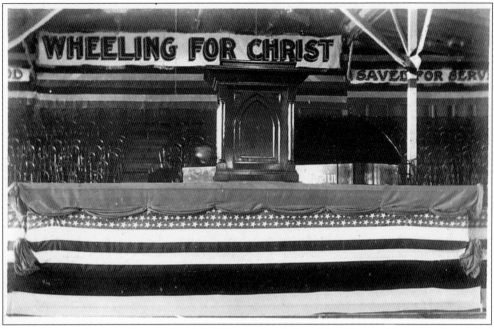

BILLY SUNDAY PULPIT. From this pulpit Billy Sunday delivered his "fire and brimstone" speeches about Wheeling's gamblers, drunkards, deadbeat husbands, and cheating businessmen. The message on the back of this postcard states that Billy Sunday would often stand on the very top of the pulpit so that the people had to look straight up towards the sky to see him. The pulpit remains at First Presbyterian Church.

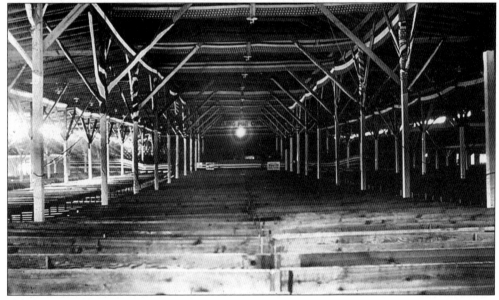

BILLY SUNDAY TABERNACLE. During the six weeks that Billy Sunday was in Wheeling he drew a total of 525,000 people with a reported 8,437 converts. Schools in Wheeling, Martins Ferry, Bellaire, Bridgeport, and St. Clairsville were dismissed on special days to allow students to attend. Educators would not allow that to happen today.

Seven
SCHOOLS AND BANKS

WARWOOD SCHOOL. This is the North Warwood School as it appeared in 1919. It was a square wooden structure situated on the northeast corner of Warwood Avenue and 22nd Street. It was demolished when the grade school was built in the 1940s. Assaro's Garage is now on the same spot.

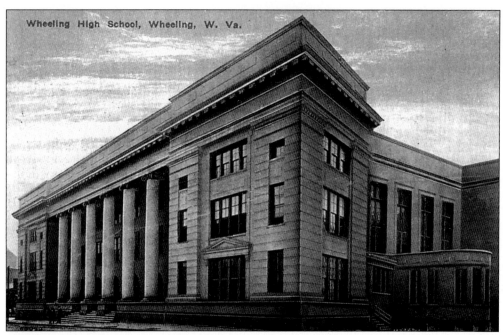

Wheeling High School, Wheeling, W. Va.

WHEELING HIGH SCHOOL. In 1897, the first high school opened in the Maxwell mansion at 2100 Market Street. The building on this postcard was constructed in 1909 and the school opened in April 1910. The reason it was built was because some prominent Wheeling citizens took a tour of the new high school in Steubenville, Ohio and reported what they saw to the local newspapers. We couldn't be outdone.

LINSLY MILITARY INSTITUTE. Students moved into this new building at Thedah Place in September 1925 and remained there until 1968 when Banes Hall was completed. The building was then leased by Wheeling Pittsburgh Steel Corporation as a computer center. It was razed in 1996. A Super Kroger store is now on the site.

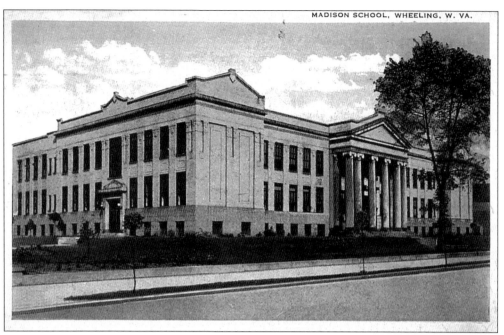

MADISON SCHOOL. This school faced Broadway, Zane, and York Streets and was built in 1916 at a cost of $92,000. An addition was added in 1930. This is the school that movie star Joanne Dru and game show host Peter Marshall attended in their youth.

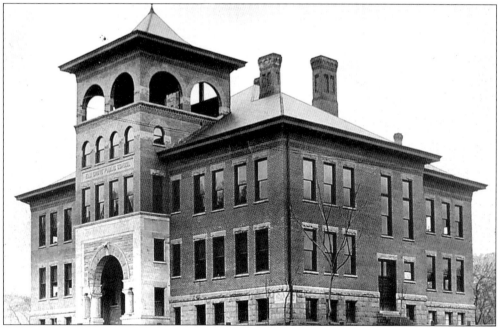

KRUGER STREET SCHOOL. The Kruger Street School, built over an Indian burial ground, was opened in March 1907 to both elementary and high school students. It was actually called Elm Grove School, as can be seen on the building, but since it was on Kruger Street it picked up that nickname and it stuck. It is now a very fine toy and train museum.

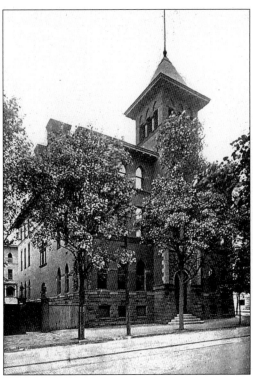

ST. JOSEPHS SCHOOL FOR BOYS. St. Josephs was a Catholic high school for boys. It was erected at the corner of 14th and Byron Streets in 1896. The Xaverian Brothers took over instruction in 1898. In September 1912, it was changed to a regular four-year high school. This 10-room facility was remodeled in 1923. The school's drum corps was called the pride of Wheeling.

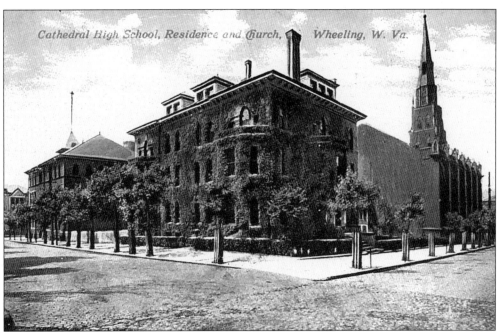

CATHEDRAL HIGH SCHOOL, RESIDENCE AND CHURCH. An interesting event took place at the Bishop's residence in 1853. During the Apostolic Nuncio's visit from Rome, a party of know-nothing members planned to harm the Nuncio. When they arrived at the residence they were met by a body of armed Irish Catholics who had surrounded the building. The Nuncio left safely.

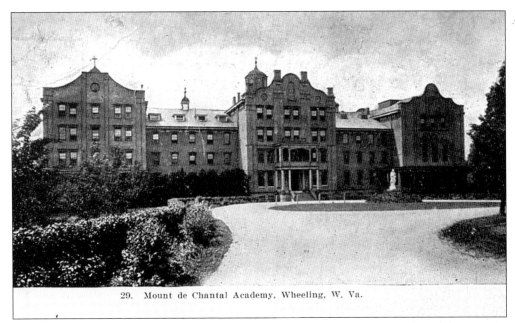

29. Mount de Chantal Academy, Wheeling, W. Va.

MOUNT DE CHANTAL ACADEMY. The current academy building was erected on Washington Avenue in 1865. It opened after Bishop Whelan and the Sisters of the Visitation formed the Wheeling Female Academy. After the Civil War, Mount de Chantal gave refuge and education to young Southern women whose families were made destitute by the conflict. Gen. Robert E. Lee wrote to the Sisters thanking them for their charity.

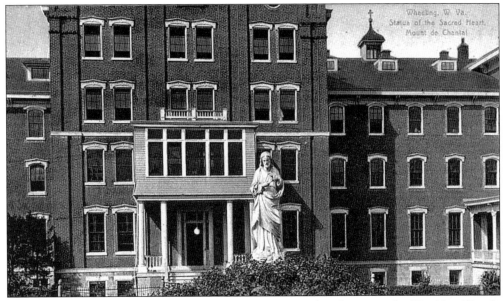

STATUE OF THE SACRED HEART. The artist George P.A. Healy, whose portrait of President Lincoln hangs in the National Portrait Gallery, sent five daughters to Mount de Chantal in the mid-19th century. He assisted with major fund-raising campaigns at the school. Mr. Healy painted a portrait of Gen. William T. Sherman, which was raffled off during a fair held at the school in 1866. The proceeds went to help veterans.

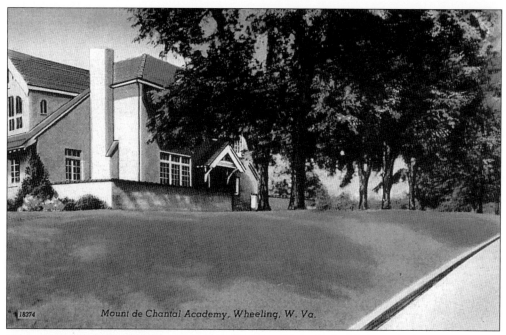

Mount de Chantal Academy, Wheeling, W. Va.

MOUNT DE CHANTAL ACADEMY. A group of private citizens built this house in 1911 as a summer retreat and eventual year-round residence for the Bishop of the Diocese and numerous other clergy. This mission-style house is rumored to be haunted. Sightings are reported to be more frequent around the season of Lent.

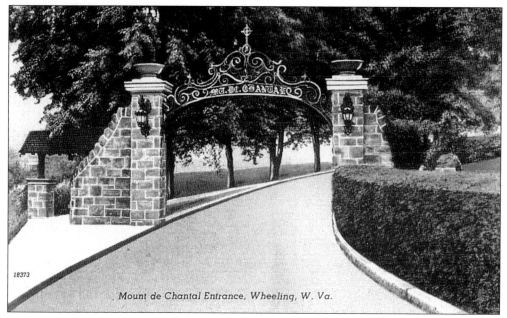

Mount de Chantal Entrance, Wheeling, W. Va.

MOUNT DE CHANTAL ENTRANCE. Many interesting students have passed through the entrance to this stately school. Anne Elstner graduated in 1918 and went on to play Stella Dallas on the radio for over 18 years. She is in the National Broadcaster's Hall of Fame. Anna Quindlen, the Pulitzer Prize winner, also attended Mount de Chantal for awhile.

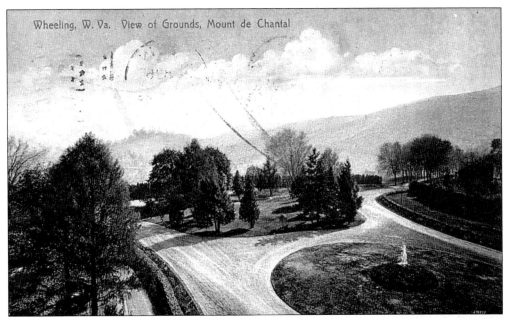

Wheeling, W. Va. View of Grounds, Mount de Chantal

A VIEW OF THE GROUNDS AT MOUNT DE CHANTAL ACADEMY. At the beginning of the Civil War, a section of the Steenrod Farm was purchased, and Bishop Whelan employed an architect to design the academy. The architect was entrusted with the money for the construction, but he absconded with the funds and the plans. This didn't stop Bishop Whelan as he found a way to complete the school.

A Corner of the Grounds
Visitation Academy
Mount de Chantal
Wheeling, W. Va.

A CORNER OF THE GROUNDS AT THE MOUNT DE CHANTAL ACADEMY. For a number of years the academy was nearly self-sufficient as some of the property was used as a farm. Originally, the grounds contained a greenhouse, a working farm with livestock, vineyards, and fields of vegetables. There was also a cemetery to bury the sisters.

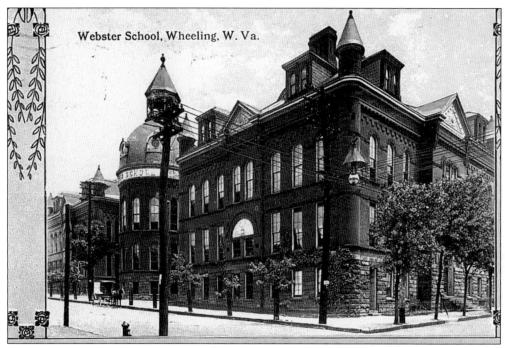

Webster School, Wheeling, W. Va.

WEBSTER SCHOOL. The first school was condemned in 1891 and this building was erected between 1892 and 1893 at a cost of $65,000. It was the largest grammar school in the state and was located at the southeast corner of Eoff and 26th Streets. It has since been razed.

WEST LIBERTY STATE COLLEGE. West Liberty State College was chartered in 1837 as West Liberty Academy through the efforts of Rev. Nathan Shotwell. The West Liberty Normal School came into existence in 1870 to provide a program of teacher training. In 1930, it became West Liberty State Teacher's College. Mark Murphy, a member of the Green Bay Packers Hall of Fame, played football at this school.

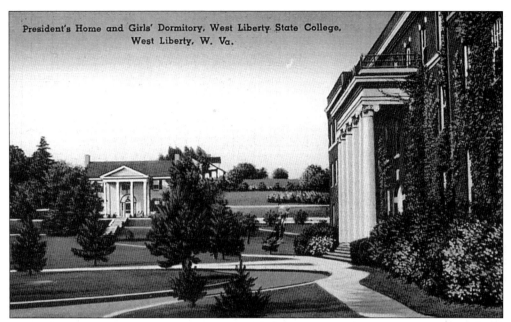

PRESIDENT'S HOME AND GIRL'S DORMITORY, WEST LIBERTY STATE COLLEGE. Colonial Heights served as the president's home and was first occupied in December 1936. Shaw Hall was built in late 1919 and was occupied the following year as a girl's dormitory.

SARA TRACY HALL, WHEELING JESUIT UNIVERSITY. Catholic Bishop J. Donahue met Miss Tracy while on board a ship to Italy. They became friends over a game of chess and when she died in 1904 she left her entire estate to the Bishop, who invested the money for future charitable causes.

WHELAN HALL, WHEELING JESUIT UNIVERSITY. Ground was first broken for Wheeling Jesuit College on November 24, 1953. The school was made possible from the original gift of Sara Tracy. This building now serves as the faculty residence.

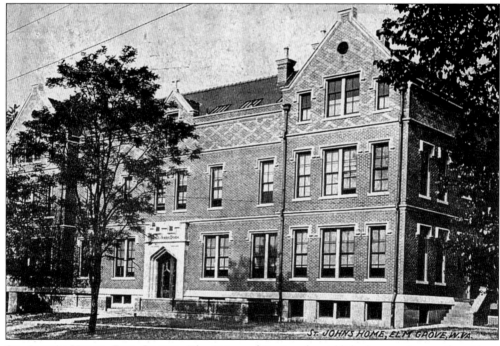

ST. JOHN'S HOME, ELM GROVE. The Sisters of St. Joseph established an orphanage for girls at Wheeling Hospital in the 1850s. The Sisters opened St. John's Home for boys in 1887 and located them in this building at Elm Grove. The girl's home was called St. Vincent's Home for Girls.

THE NATIONAL EXCHANGE BANK. The National Exchange Bank was organized in 1899 and it had more capital, surplus, and resources than any other bank in the state. Veteran ironmaster J.N. Vance was the president. Other names associated with the bank were W.E. Stone, George E. Stifel, John M. Brown, and Lawrence E. Sands.

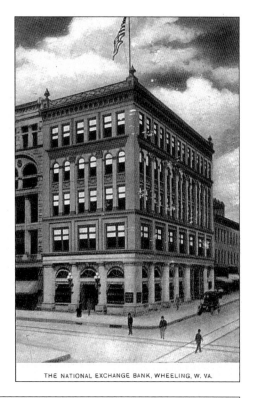

THE NATIONAL EXCHANGE BANK, WHEELING, W. VA.

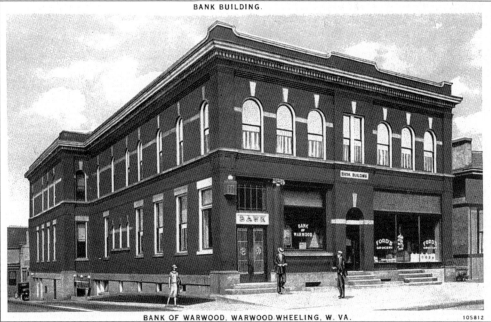

BANK OF WARWOOD, WARWOOD-WHEELING, W. VA.

BANK OF WARWOOD. This bank was formed on March 4, 1911 with a capital of $25,000 and opened at 1713 Warwood Avenue, where it remained until 1914. It later moved to 1701 Warwood Avenue. In 1921, an addition was added in the rear of the bank. The Ford Grocery Store was located in the north side of the building. There have been two daring daylight robberies at this financial institution.

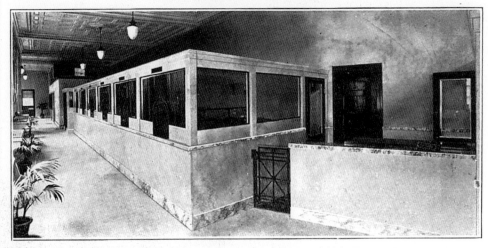

BANKING ROOM

BANK OF WARWOOD, WARWOOD, WHEELING, W. VA.

BANKING ROOM, BANK OF WARWOOD. The first floor of this bank was remodeled in 1965 at a cost of $300,000, which dramatically changed the bank's appearance. Dr. Webb's office and home on the north side of the bank's property was bought in 1967 and razed to make room for more parking. In 1971, the bank acquired the Lincoln Theatre for additional parking.

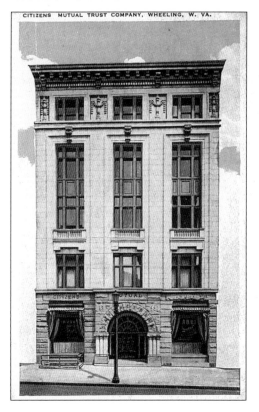

CITIZENS MUTUAL TRUST COMPANY, WHEELING, W. VA.

CITIZENS' MUTUAL TRUST CO. The Mutual Savings Bank formed on March 4, 1887 and became known as the only cooperative savings bank in West Virginia. During its first 25 years it never paid less than four percent on its deposits. It consolidated with Citizens Savings Bank to become Citizens Mutual Savings Bank. Located in the heart of the business district, it was purchased by Wheeling Dollar Savings and Trust in 1939.

CITY BANK OF WHEELING. This building was constructed in 1891 as the home of City Bank and was considered the finest office building in town. City Bank was founded as a private banking firm in 1870. This Richardsonian Romanesque building is now called the Professional Building.

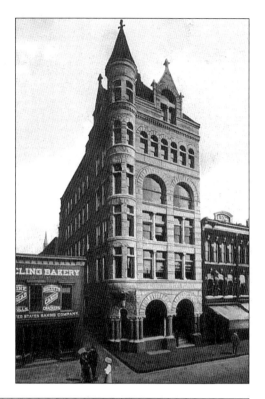

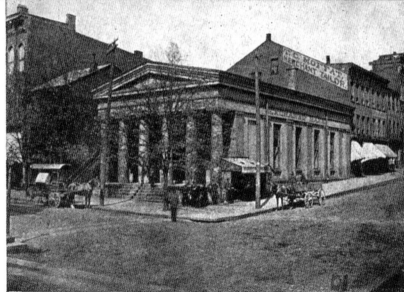

Built in 1845, torn down in 1896. Was located at corner of Twelfth and Main streets, Wheeling, W. Va.

OLD EXCHANGE BANK. This building was constructed in 1845 at the northeast corner of 12th and Main Streets. The architect was Thomas U. Walter, the man who designed a wing and the dome of the United States Capitol building. It was later razed to make way for a modern five-story building. After voluntary liquidation in August 1874, it was reorganized as the National Exchange Bank on January 1, 1899.

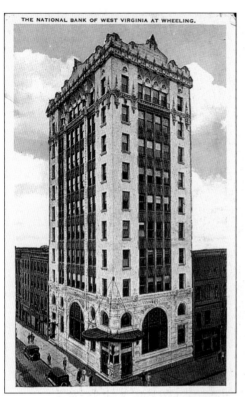

THE NATIONAL BANK OF WEST VIRGINIA AT WHEELING.

NATIONAL BANK OF WEST VIRGINIA. This bank can trace its history back to the Northwestern Bank of Virginia, which was founded in 1817. Noah Zane was its first president. This building was designed by Charles W. Bates and was completed in 1915. It is still in use as an office building.

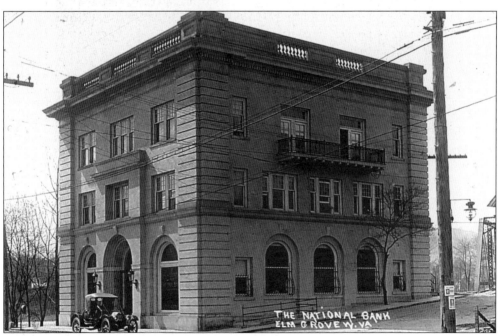

THE NATIONAL BANK ELM GROVE W. VA.

NATIONAL BANK OF ELM GROVE. The National Bank of Elm Grove was founded in 1907 by J.B. Chambers and six other bankers. They constructed this building in 1911. Shortly after moving in, the bank was broken into through a side window and the safe was blown. The robbers stole $5,000.

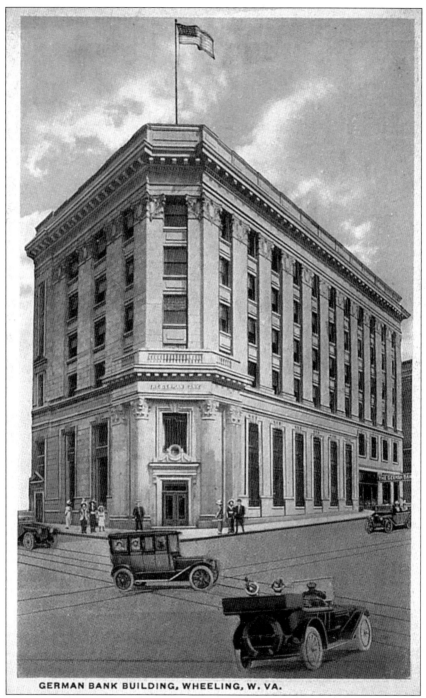

GERMAN BANK BUILDING, WHEELING, W. VA.

GERMAN BANK OF WHEELING. This building is located on the site of the former Washington Hall, which burned to the ground in 1875, killing one and injuring three. It was rebuilt in 1877. The German Bank later purchased the property and completely remodeled the bank and added two more floors. German Bank changed its name to Wheeling Bank and Trust, which then merged with Dollar Savings and Trust Company.

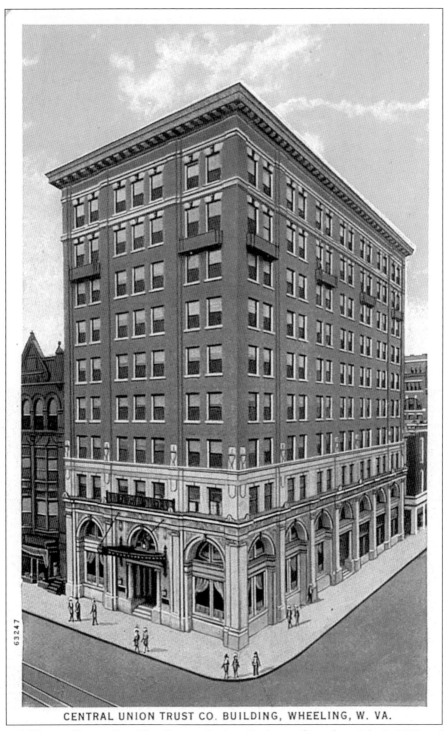

CENTRAL UNION TRUST CO. BUILDING, WHEELING, W. VA.

CENTRAL UNION TRUST CO. The Quarter Savings Bank was formed on July 1, 1901 and later changed its name to Central Union Trust Co. This structure was built on the site of the devastating "House and Hermann" fire of December 1917. It was purchased by WesBanco, Inc. in 1998.

Eight
A Day at the Park

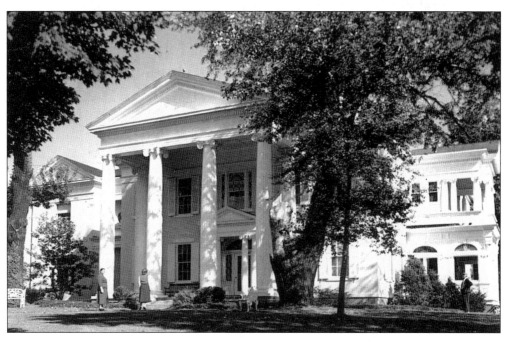

OGLEBAY MANSION. Multi-millionaire Earl Oglebay purchased an eight-room farmhouse from his mother-in-law's estate in 1901. He spared no expense in turning the property into a beautiful country estate so the family could have a summer home. Mr. Oglebay started his career in Wheeling as a banker and then moved to Cleveland where he made his fortune in shipping.

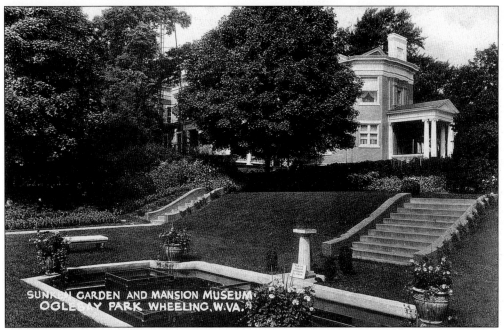

SUNKEN GARDENS AND MANSION MUSEUM. Shortly after Mr. Oglebay bought this property, he began work on his spacious gardens. He turned the land into a successful country farm and erected more than 60 buildings. This formal English sunken garden contained a lily pond, a teahouse, and fine floral displays. Many of Wheeling's couples choose to get married on this beautiful spot.

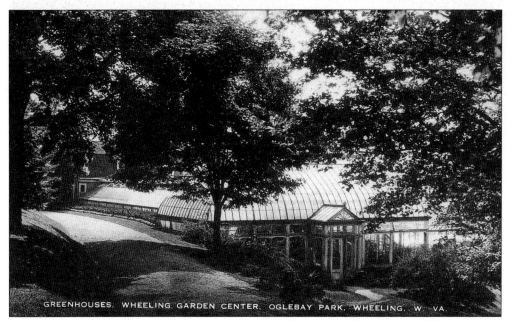

GREENHOUSE, WHEELING GARDEN CENTER. Mr. Oglebay called his estate Waddington Farms and it contained three greenhouses and the Palm House, as well as terraced gardens. The Wheeling Garden Center was formed in 1938 to promote interest in horticulture and information center on gardening activities.

94

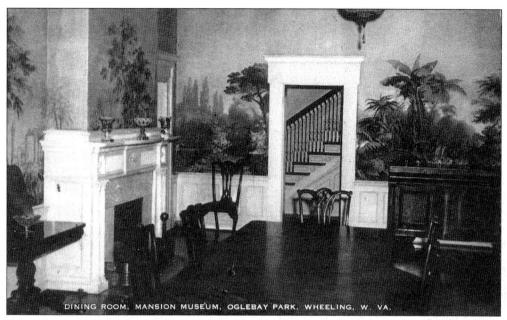

DINING ROOM, MANSION MUSEUM, OGLEBAY PARK, WHEELING, W. VA.

DINING ROOM, MANSION MUSEUM, OGLEBAY PARK. The wallpaper in this room was made by Zuber and Company in France. The pattern is called "El Dorado." The chandelier was made in Wheeling by Hobbs, Brockunier, and Company in the 1870s. This colorful room played host to many of Wheeling's social elite.

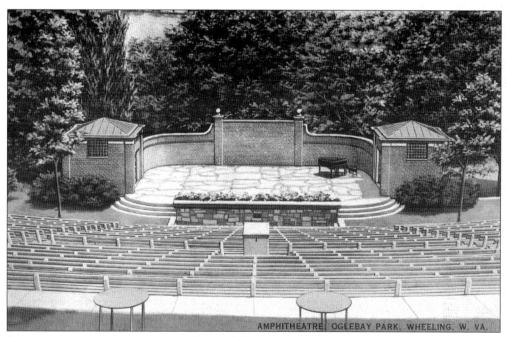

AMPHITHEATRE, OGLEBAY PARK, WHEELING, W. VA.

AMPHITHEATRE, OGLEBAY PARK. This amphitheatre was built in 1936 by the Civilian Conservation Corps. Over the years it has been the site of hundreds of plays and recitals. Thousands of Wheeling's citizens have been entertained here under the stars by such performers such as Victor Borge, Steve Allen, Robert Merrill, Benny Goodman, Count Basie, and Louis Armstrong.

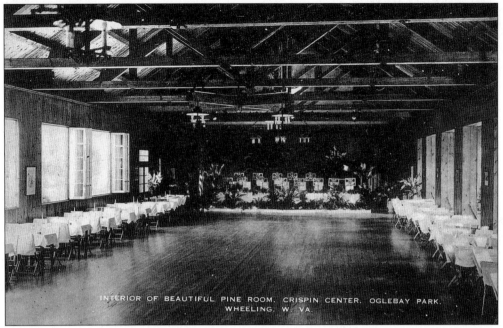

INTERIOR OF BEAUTIFUL PINE ROOM, CRISPIN CENTER, OGLEBAY PARK, WHEELING, W. VA.

CRISPIN CENTER COMPLEX, OGLEBAY PARK. Crispin Center was named after Crispin Oglebay, the nephew of Earl Oglebay. All of this property was left to the people of Wheeling for educational and recreational purposes by Mr. Earl Oglebay. Crispin worked very hard to convince the city fathers to accept this magnificent gift.

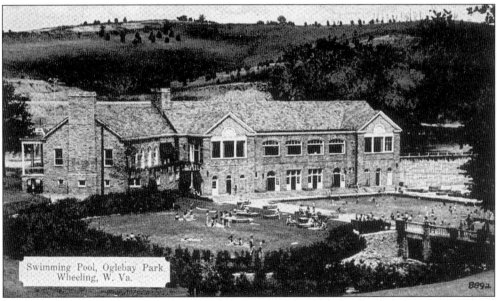

Swimming Pool, Oglebay Park, Wheeling, W. Va.

SWIMMING POOL, OGLEBAY PARK. This pool is part of the Crispin Center and is adjacent to an 18-hole golf course. The pool measures 75 by 65 feet with an adjoining wading pool and opened in August 1937. Both Buster Crabbe and Johnny Weismuller swam in this pool during a visit. The Pine Room has a large dance floor, lounge, and club house for golfers. There are now four 18-hole golf courses at the park.

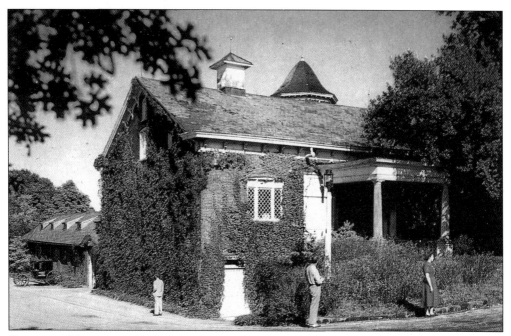

CARRIAGE HOUSE AND FRONTIER TRAVEL GALLERY, OGLEBAY PARK. Mr. Earl Oglebay built this structure in 1906 as a stable and carriage house. The park was using this house as a museum of travel when it was destroyed in a fire. The museum contained a Conestoga wagon, sleigh, carriages, and other antiques at the time of the fire. They were all destroyed.

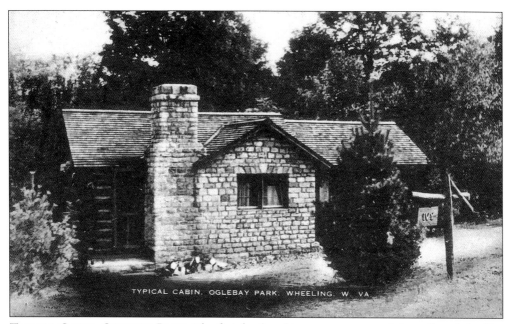

TYPICAL CABIN, OGLEBAY PARK. The first family cabins were constructed from discarded utility poles by workers from the Civilian Conservation Corps after federal funds became available in 1936. They have all been replaced with 49 modern cottages.

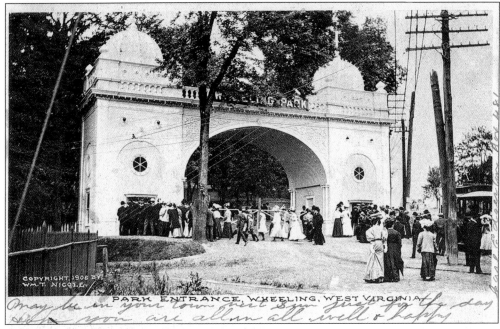

WHEELING PARK ENTRANCE. This is how the entrance appeared around 1906 when it was owned by Wheeling Traction Co. and brewery owner Anton Reymann. The park was the last stop on the streetcar line. It was bought in 1924 by wealthy citizens and given to the city of Wheeling on December 24th of that year, a great Christmas gift to the citizens of Wheeling.

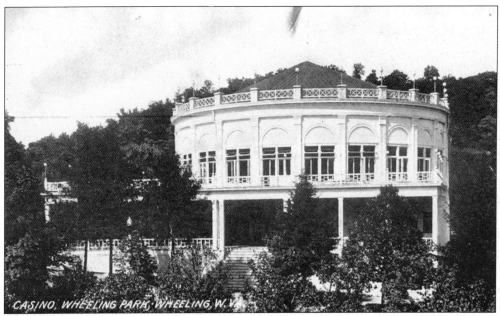

CASINO, WHEELING PARK. The Wheeling and Elm Grove Railroad Co. bought the Hornbrook estate in 1901 and built an amusement park. This grandiose casino was built in 1904. The famed Sarah Bernhardt appeared there in 1906. It burned to the ground in September 1925, a year after the city obtained the park.

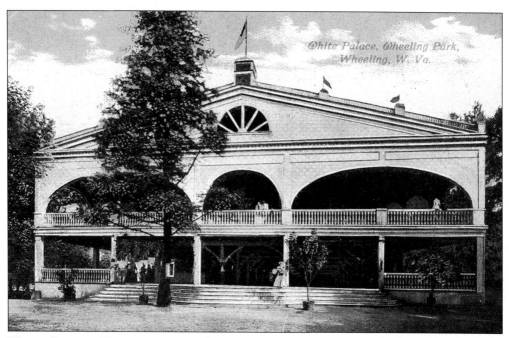

WHITE PALACE, WHEELING PARK. The White Palace was built after the casino burned down in 1925. It was 108 feet wide by 144 feet in length and cost $125,000. The second floor was for summer dancing and the ground level was for picnics and other functions.

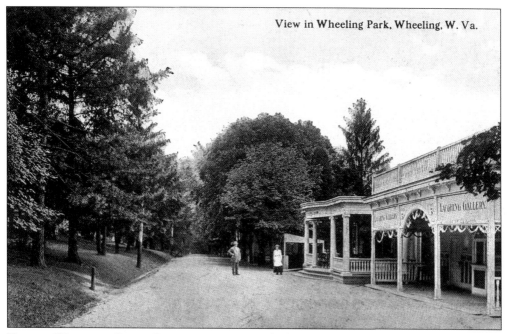

VIEW IN WHEELING PARK. Ornate amusement arcades lined Lover's Lane. The Laughing Gallery is the first building on the right.

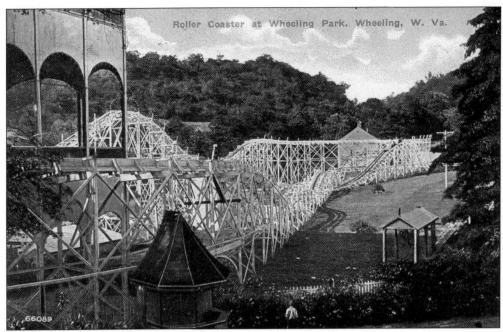

ROLLER COASTER, WHEELING PARK. This coaster was one of the main attractions at Wheeling Park. Lines formed every summer day at this 60-foot high amusement. Each of its 3 cars held 12 adults. Two cars were constantly in use with a third car held in reserve. Today a parking lot and exit road sit on this spot.

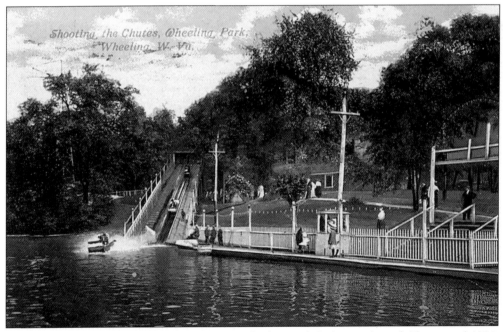

SHOOTING THE CHUTES, WHEELING PARK. Wheeling Park had a number of rides around 1906, including a roller coaster, circle swing, merry-go-round, scenic railway, and a water slide called shoot-the-chutes. All of these attractions were removed *c.* 1924–1925.

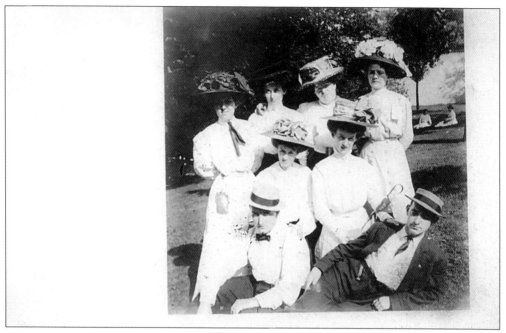

A DAY AT WHEELING PARK. Everyone who was anyone would get dressed-up in their best outfits to visit Wheeling Park. Note the large hats on the young ladies. Arch Imhoff is the young man on the right and his wife Bertha Conner has her hand on his shoulder.

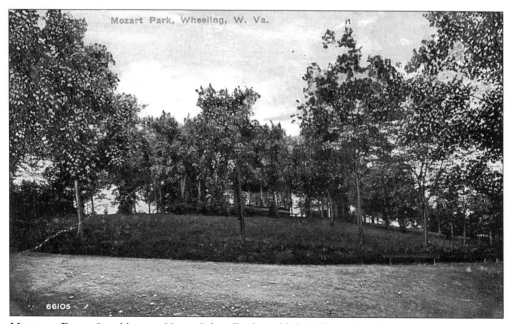

MOZART PARK. Local brewer Henry Schmulbach established this park and beer garden in 1893. He built an incline rail to take passengers from 43rd Street to the top of the hill. The incline operated until 1907. The park had a roller coaster, bowling alley, bike track, and a large dance hall.

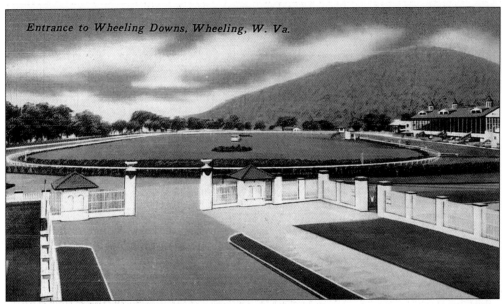

ENTRANCE TO WHEELING DOWNS. In 1945, after a decade and a half of existing under receivership, the State Fair track was bought at public auction for $262,500. The new owner was Wheeling gangster "Big Bill" Lias. He would spend a small fortune on the facility to transform it into the most beautiful half-mile track in the country.

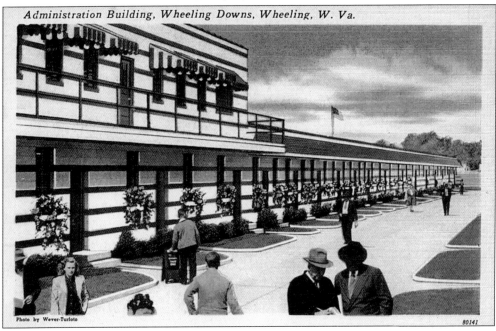

ADMINISTRATION BUILDING, WHEELING DOWNS. In its heyday as a thoroughbred racetrack, this facility had 400 employees. "Big Bill" Lias had his own 13-man police force headed by the former chief of police. Mr. Lias was arrested a number of times for bootlegging and gambling. He served two terms in the federal prison system. The government also tried, unsuccessfully, to deport him as an illegal alien.

Part of the Plant Motor Fleet, Wheeling Downs, Wheeling, W. Va.

THEY'RE OFF! At Wheeling Downs there was usually a nine-card race with seven or eight horses in each race. The starting official is in the small tower on the right. Before each race the track was harrowed and sprinkled to make it safe for the horses and jockeys.

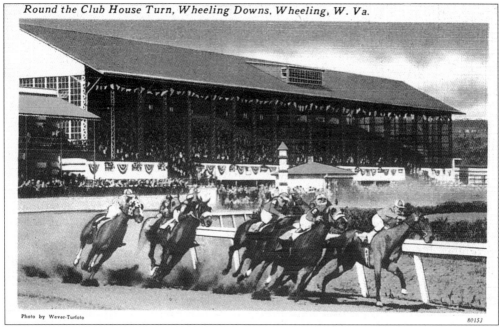

Round the Club House Turn, Wheeling Downs, Wheeling, W. Va.

Photo by Wever-Turfoto

80153

ROUND THE CLUB HOUSE TURN, WHEELING DOWNS. Willie Hartack, the Hall of Fame jockey, honed his skills on this track early in his career. He would go on to win five Kentucky Derby races. Wheeling Downs was the first race track to compensate owners whose horses were injured during the race and had to be destroyed.

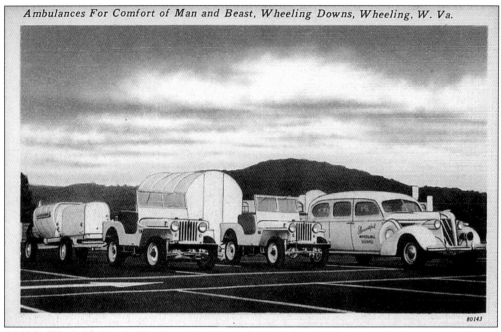

Ambulances For Comfort of Man and Beast, Wheeling Downs, Wheeling, W. Va.

80143

AMBULANCES, WHEELING DOWNS. The Downs had a four-bed hospital on the premises. A doctor and nurse were available on race days. The jeep in the middle of the postcard was to carry horses.

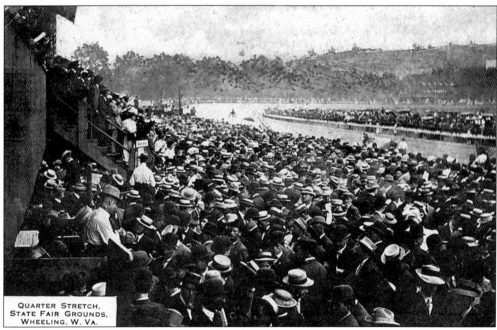

QUARTER STRETCH, STATE FAIR GROUNDS, WHEELING. W. VA.

QUARTER STRETCH, STATE FAIR GROUNDS. Thousands came to risk their wages each race day. The West Virginia State Fair started in 1881 and remained viable until 1931. Hall of Fame driver Pop Geers was killed on this track during a State Fair sulky race in September 1924.

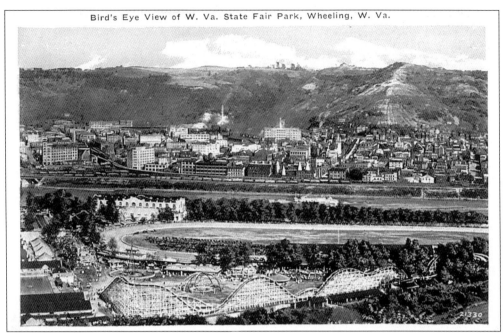

Bird's Eye View of W. Va. State Fair Park, Wheeling, W. Va.

BIRD'S EYE VIEW, WEST VIRGINIA STATE FAIR PARK. This postcard shows the State Fair racetrack, auditorium, and swimming pool, which was the largest in the state at the time. The roller coaster called "the Dips" was lost in the terrible 1936 flood. Notice the glass-making kilns of the Warwick China Company across the river in Wheeling.

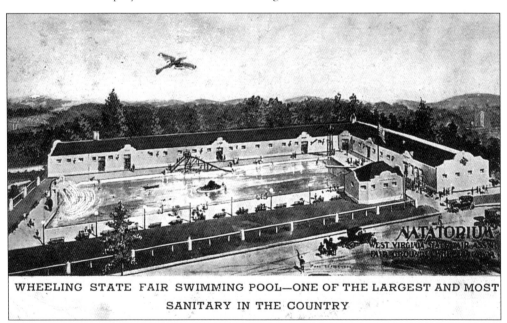

WHEELING STATE FAIR SWIMMING POOL—ONE OF THE LARGEST AND MOST
SANITARY IN THE COUNTRY

WHEELING STATE FAIR, SWIMMING POOL. This pool opened on the State Fair grounds at the south end of Wheeling Island in 1917. It was advertised as the "most sanitary" in the country. The pool was fed by pure well water and was heated. There were also bath houses and lockers. Private swimming lessons were available.

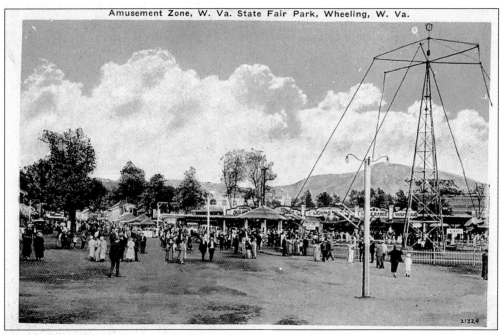

AMUSEMENT ZONE, WEST VIRGINIA STATE FAIR. An amusement park was located to the north of the race track. There were games of chance, exhibits, and places to get something to eat. The amusement at the right was the airplane ride. The big event of the 1929 State Fair was Wilno, the human projectile, a new act imported from Europe. Wilno was shot out of a cannon.

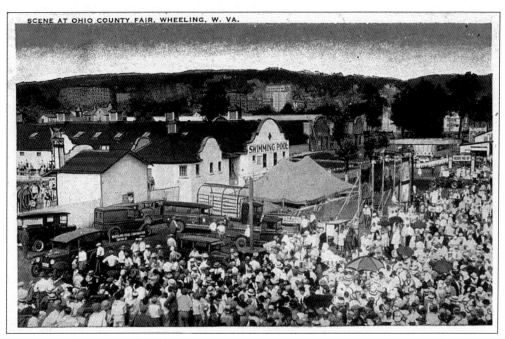

SCENE AT OHIO COUNTY FAIR, WHEELING, W. VA.

SCENE AT THE FAIR. The rust-colored truck in the left center has a sign that says "Wheeling Steel Corp." A swimming pool, bath house, and locker rooms are in the middle of the card.

AIRSHIP AT THE STATE FAIR. A lighter-than-air balloon would have been a real crowd pleaser at the state fair. This card is dated from 1910 but could actually be from a few years earlier.

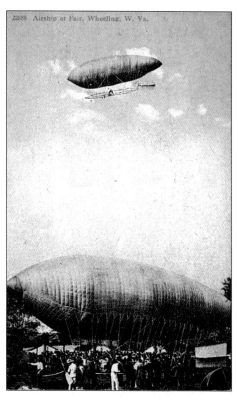

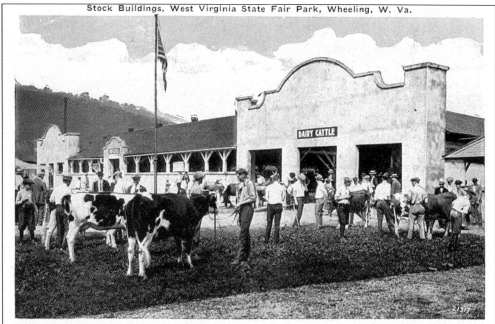

STOCK BUILDINGS, WEST VIRGINIA STATE FAIR. These buildings exhibited dairy cattle, horses, sheep, and hogs. Prizes were awarded and ribbons were given for the best stock. Notice the man's knickers on the right.

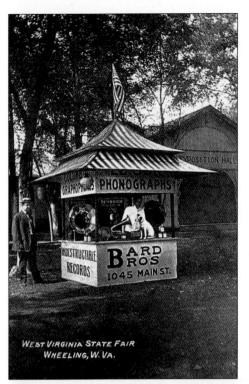

BARD BROTHERS PHONOGRAPH BOOTH. The fair's equipment was almost completely annihilated in the flood of 1884. Subsequent floods would also cause the damage that led to the end of the fair in 1936. Notice the dog peering into the phonograph, which looks like the old RCA advertisement.

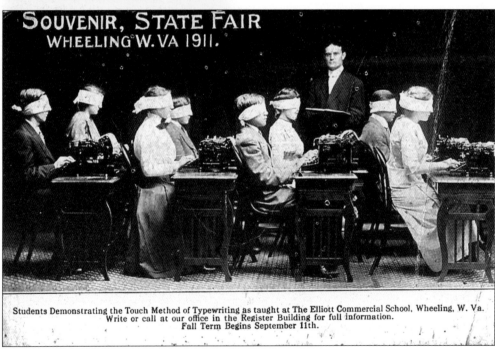

SOUVENIR, STATE FAIR, WHEELING, 1911. Each fair on Wheeling Island would have exhibitions of agriculture and industrial products. This advertising postcard shows students learning to use the touch method of typing by being blindfolded. They were students of the Elliot Commercial School.

Nine
A NIGHT ON THE TOWN

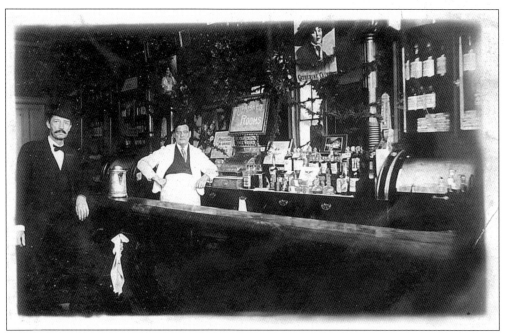

BARTENDER AND PATRON. A typical turn-of-the-century saloon like this would have been visited by local steelworkers, glassmakers, and nailers. The industrial workers frequented such taverns to "wash away the mill dust from their throats," as they loved to say. The steelworkers had a nickname for their favorite drink. It was called a puddler's cocktail and consisted of a shot of whiskey with a locally made beer chaser.

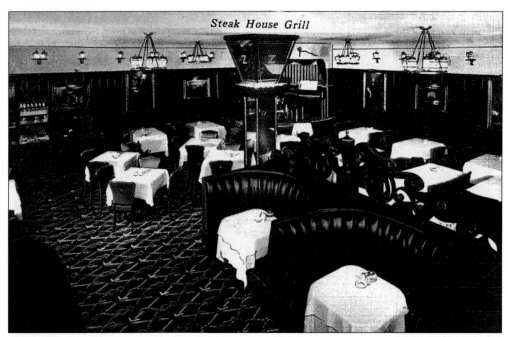

STEAK HOUSE GRILL. The Steak House was leased by Eric Halverson and William Dolan in 1955 from the George brothers of Bridgeport, Ohio. The well-known oak-paneled grill room had deep carpets and leather upholstered booths and chairs. William Katricz was the popular chef.

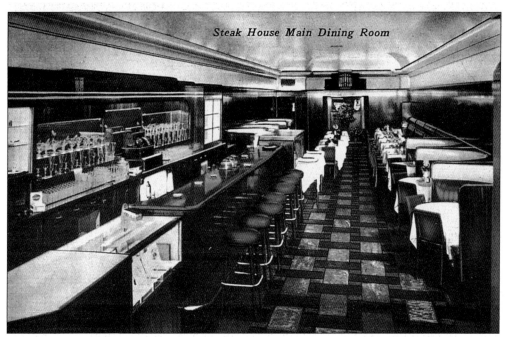

STEAK HOUSE, MAIN DINING ROOM. The steakhouse advertised itself as the "most famous eating establishment between New York and Chicago." It was located at 1429 Market Street.

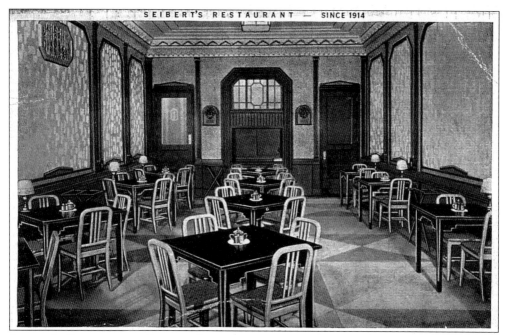

SEIBERT'S RESTAURANT. George Seibert opened this restaurant in 1914 along Route 40 in Elm Grove. During Prohibition, Mr. Seibert was a bootlegger and for a while a partner of "Big Bill" Lias in the numbers racket. Later this building was used as the offices of the board of education.

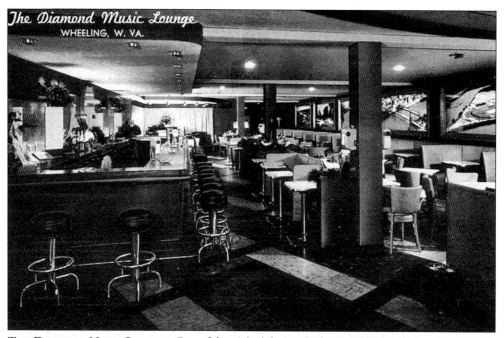

THE DIAMOND MUSIC LOUNGE. One of the nightclubs in which "Big Bill" Lias had an interest, this hangout was located at 1411 Market Street. Visible to the right side of the postcard is Lias's Wheeling Downs racetrack in a painting on the wall. The building was destroyed by fire in 1950.

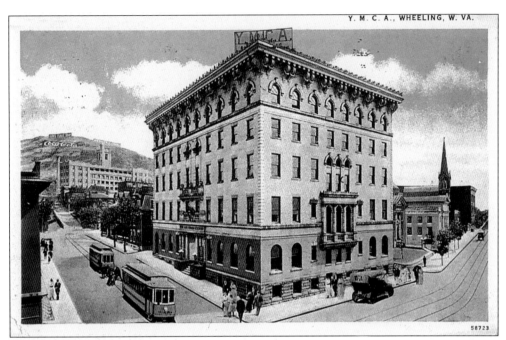

YMCA BUILDING. The YMCA was organized on February 9, 1859. The YMCA rented a space at 1122 Market Street from 1885 to 1889. Later they moved into the Maxwell mansion at the corner of Market and 20th Streets until 1910 when this structure was erected. It contained a swimming pool, basketball court, and a running track. It is now an office building.

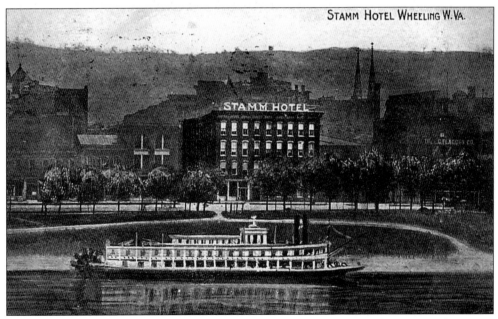

STAMM HOTEL. For many years this was an extremely popular lodging place for river travelers. It was constructed around 1841. Henry Stamm and Frank Unruh purchased the lot for $8,000. The building was razed in 1945.

THE WINDSOR HOTEL. A hotel has been on this site since 1815. In 1913, E.B. Carney built the current 12-story building with a grand opening on January 1, 1914. Many famous people have stayed in this hotel including Spencer Tracy, Clark Gable, Jim Thorpe, Jack Dempsey, and Max Baer, as well as Presidents Franklin D. Roosevelt, Harding, Hoover, and Coolidge. Today it serves as an apartment building.

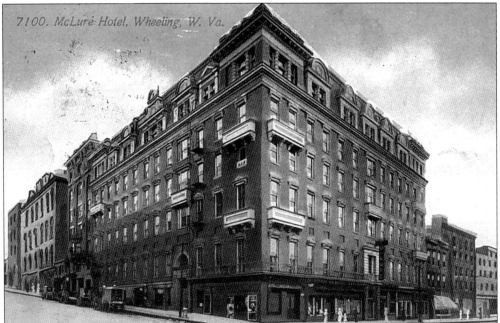

McLure Hotel. The McLure Hotel grand opening was held March 4, 1852. At first, guests were served by the hotel owner's slaves. E.M. Statler, who built the Statler Hotel empire, began his career here as a 13-year-old bellboy. He worked his way up to assistant manager and then moved on to Buffalo, New York where he built his first grand hotel. He always came back to Wheeling banks for financing. This 315-room hotel was the site where Senator McCarthy delivered his famous "Communists in the State Department" speech, which resulted in the McCarthy hearings. Fourteen United States Presidents have stayed here, including U.S. Grant, Teddy Roosevelt, J.F. Kennedy, Richard Nixon, and Dwight D. Eisenhower, to name a few.

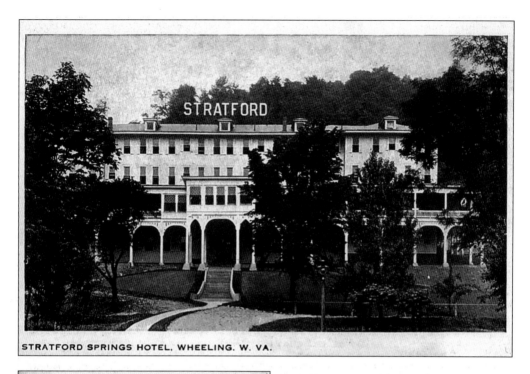

STRATFORD SPRINGS HOTEL, WHEELING, W. VA.

INSTRUCTIONS
to guests preparing to
SMOKE IN BED

1. Call the Office and notify the Management where you wish your remains sent, as it is a matter of record that a very high percentage of Hotel fires are caused by this careless practice.
2. Notify guests in adjoining rooms of your intention of endangering their lives; so that they may take necessary precautions to protect themselves.
3. Go to the corridor and locate the nearest fire escape, so that if you are fortunate enough to escape your room, you may reach safety.
4. Now sit down and think how foolish it is for you to take this risk----you may enjoy your smoke while thinking it over.

Business may be good, but we do not have guests to burn, so please--
Help US to Protect YOU!

HOTEL WHEELING
10th and Main Streets
Wheeling, W. Va.

STRATFORD SPRINGS HOTEL. The Stratford Springs resort was once considered the gem of Wheeling. Officially opened for business in 1907, the magnificent 84-room resort served guests from the top of the social register for parties, weddings, opulent dances, and other functions. Some of the upper-crust of Wheeling lived in the hotel for part of the year. It burned to the ground in 1918 and was not rebuilt.

HOTEL WHEELING, INSTRUCTIONS. The Hotel Wheeling was constructed around 1906 on the site of the old Wheeling Hotel. This five-story building had 75 rooms. This is a tongue-in-cheek instruction card for smoking in bed. L.S. Good, a prominent local businessman, bought the hotel in 1926 for $153,000

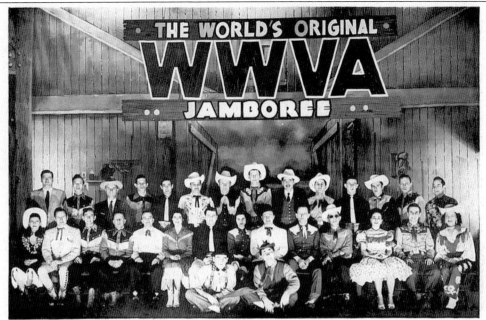

Front Row L to R: Vickie Lee Camp, Gene Hooper, Roy Ingram, Bud Messner, Abner Doolittle, Chickie Williams, James Crawford, Marion Durham, Hardrock Gunter, Buddy Durham, Marion Martin, Wilma Lee, Dusty Owens and Bebe Bernard.

Back Row L to R: Lee Sutton, Bill Fleegle, Doc Williams, Jack Thomas, Bob Gallion, Hal Camp, Big Slim, Curley Holiday, Stoney Cooper, Cy Williams, Woody Woodham, Bud Kilgore, Bob Thomas and Paul Jackson.

Front: Smokey Pleacher and Crazy Elmer.

WWVA JAMBOREE. The first broadcast of the original WWVA Jamboree was January 7, 1933. The response was so great to this country-and-western show that management scheduled a live performance at the Capital Theatre. That show was held at midnight on April 1, 1933. A total of 3,266 persons watched the show and 1,000 were turned away at the door. The show has been going on ever since

Victoria Theatre, Wheeling, W.Va.

THE VICTORIA THEATRE. This venue opened in 1904 as the Victoria Vaudeville Theatre. In 1908 a renovation increased the seating to 727. Mr. George Schaeffer was the owner from its opening day until his death. Katherine Hepburn, Lawrence Welk, and George Burns performed here.

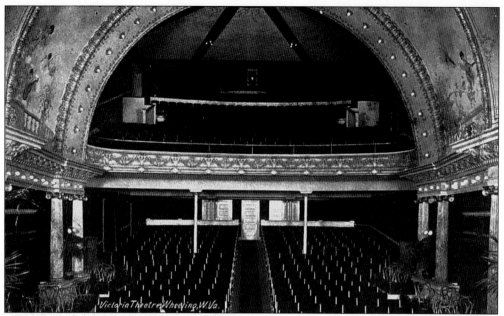

INTERIOR OF THE VICTORIA THEATRE. Inside this theatre are magnificent Romanesque columns along the stage. The balcony includes two private boxes. Movies were last shown here in 1987. In 1996 the theater was completely renovated and is being used as a vaudeville theater once again. Shows are held every Saturday night.

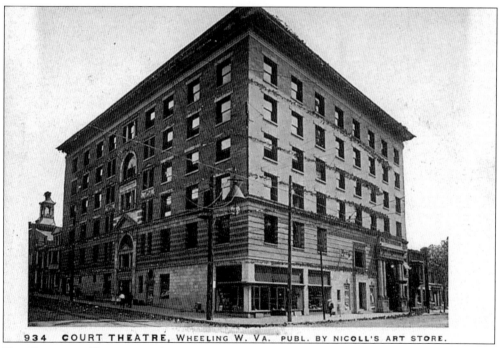

934 COURT THEATRE, WHEELING W. VA. PUBL. BY NICOLL'S ART STORE.

THE BOARD OF TRADE AND COURT THEATRE. In 1901–1902, the Board of Trade Building was erected on the site of a courthouse for $170,000. The Court Theatre was completed at the same time on the first floor. It officially opened in September 1902 with the musical comedy *Miss Simplicity*.

THE VIRGINIA THEATRE. The Virginia Theatre was named after Mrs. Hiraim C. (Virginia) Miller, the daughter of the first owner, Charles Feinler. Movies, concerts, and stock theater productions were among the events held in this facility. Famous performers who have graced this stage include Marian Anderson, Arthur Rubenstein, Olivia de Havilland, Beverly Sills, Benny Goodman, Roberta Peters, Blackstone the Magician, and even Amelia Earhart, who spoke to an audience in 1933.

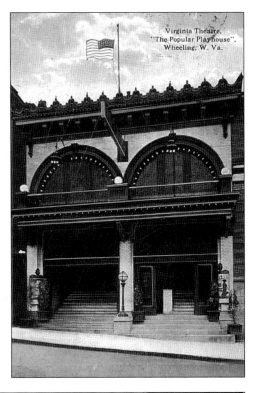

Virginia Theatre,
"The Popular Playhouse",
Wheeling, W. Va.

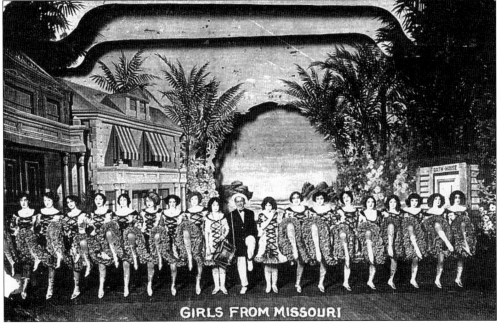

GIRLS FROM MISSOURI

MISSOURI GIRLS. This burlesque show played in Wheeling the week of February 5, 1912. The program was called "The Monte Carlo Girls." There was a matinee on Monday and one show each evening. One of the performers was known as Princess Olga. After leaving Wheeling, the girls traveled to Washington, D.C. for their next production.

117

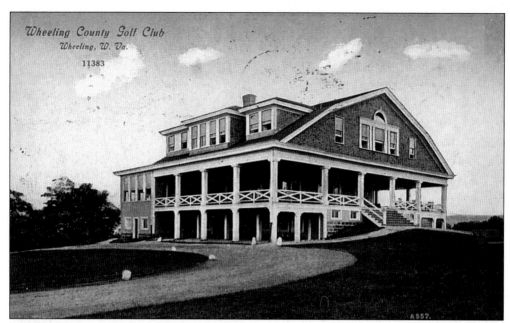

WHEELING COUNTRY CLUB. This country club was founded in 1902 by prominent civic leaders and businessmen of Wheeling, such as Oglebay, Bloch, Franzheim, and List. The clubhouse was open for customers in 1905. It was designed by Wheeling architect Frederick F. Faris. The initiation fee was $100 and annual dues were another $100. It was among the first 25 golf clubs in the United States.

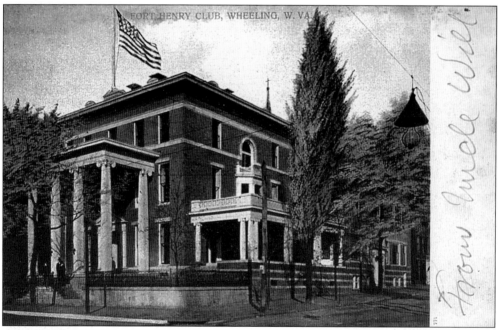

THE FORT HENRY CLUB. This club was founded in 1890 by the top businessmen in town. The club purchased the Howell mansion at 1324 Chapline Street and closed its doors to women in 1891. A number of celebrities visited the club, including Jimmy Stewart, President Hoover, Walter Pidgeon, Charles Lindbergh, and Babe Ruth.

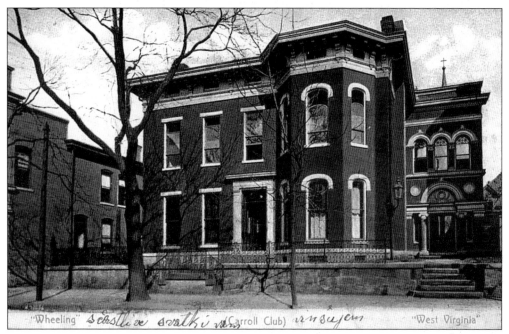

"Wheeling" *schsllie soalki i ne*(Carroll Club) *ernscafem* "West Virginia"

CARROLL CLUB. The Carroll Club Building was originally constructed as a grand home for Judge James Paull, the former mayor of Wheeling. It was purchased by James W. Paxton in 1885 and then the Knights of Columbus (The Carroll Club) in 1895. Both William Jennings Bryan and Guiglielmo Marconi spoke here.

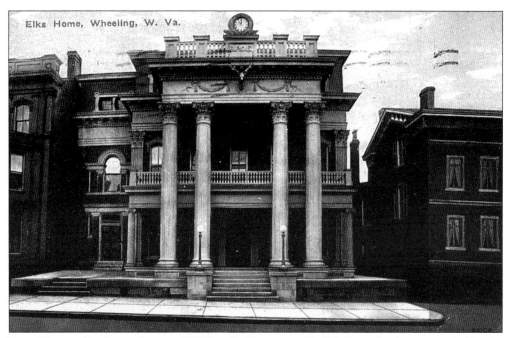

ELKS HOME. The former home of William B. Simpson at 32 15th Street has been occupied by the Wheeling Elks Lodge #18 since 1904. This imposing building has Corinthian columns which adorn its front face. This Elks Lodge was formed in 1888.

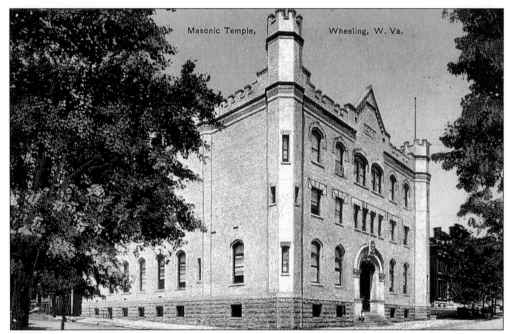

Masonic Temple, Wheeling, W. Va.

MASONIC TEMPLE. The Masonic Temple was constructed in 1907 at a cost of $110,000 and dedicated in June 1908. A large fire, caused by waste material in the basement, completely destroyed this magnificent Scottish Rite Cathedral on March 4, 1915. Local papers reported that the police made certain that none of the spectators had their pockets picked during the blaze.

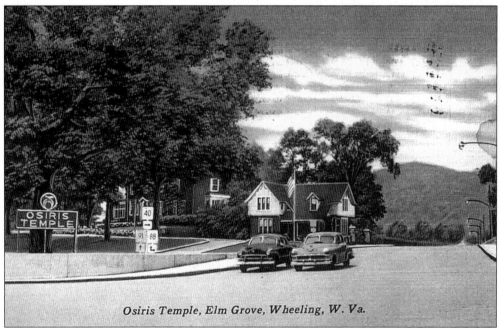

Osiris Temple, Elm Grove, Wheeling, W. Va.

OSIRIS TEMPLE, ELM GROVE. The Osiris Temple was formed in Wheeling as a social organization in 1887. After the turn of the century, the Shriners devoted their fund-raising to Shriner hospitals. The Wheeling lodge bought the Shepherd mansion in 1925 and it is still in use today.

Ten
MISCELLANEOUS
MEMORIES

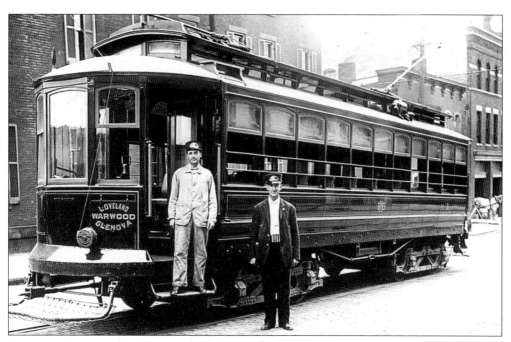

ELECTRIC TROLLEY CAR. On March 15, 1888, Wheeling became the third city in the United States to have electric trolley cars. This car (#3) took passengers from downtown Wheeling to Warwood. Mr. Tustin is the motorman standing on the step and Mr. Bentfield, the conductor, is wearing the coin changer around his waist.

WARWOOD HOME. This is a typical Warwood Avenue home in the early 1900s. This house was owned by Silas Conner and his wife Libby. He worked for Scott Lumber as a driver. The home still stands at 1708 Warwood Avenue and is owned by C.P.A. Ernest Bentfield, whose grandfather is the conductor in the previous postcard.

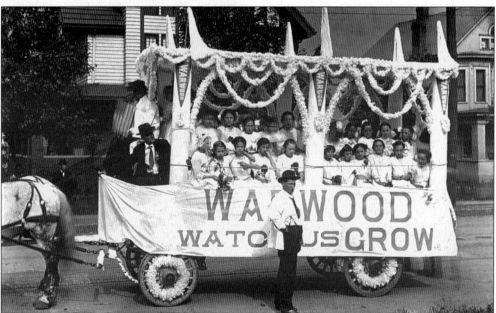

WARWOOD—WATCH US GROW. Warwood is a patriotic, working-class neighborhood that adopted the motto "Watch Us Grow" in the early 1900s. This float was part of a parade that was forming on Warwood Avenue at 20th Street.

WARWOOD AVENUE. Arch Imhoff and his wife Bertha are standing on the trolley tracks along unpaved Warwood Avenue. Bertha's home is the house behind her right shoulder. This young couple married and had three children. Arch worked as a hand roller for Pollock Stogies and later sold insurance. He was an expert on the Civil War and smoked Marsh Wheeling Stogies.

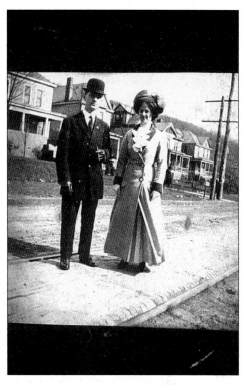

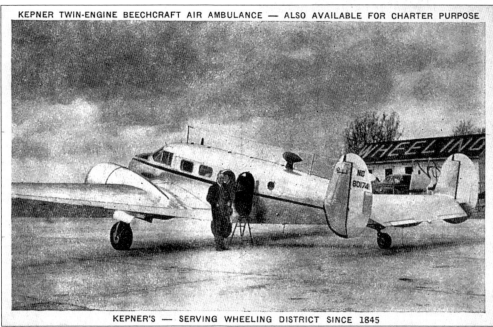

KEPNER TWIN-ENGINE BEECHCRAFT AIR AMBULANCE — ALSO AVAILABLE FOR CHARTER PURPOSE

KEPNER'S — SERVING WHEELING DISTRICT SINCE 1845

KEPNER AIR AMBULANCE. Kepner Funeral Home used this twin-engine Beechcraft airplane as an air ambulance and as a charter for Wheeling's elite businessmen. The message on the back of the postcard tried to alleviate fears of flying by reassuring that the plane could "take-off, fly or land with either one of its engines alone if necessary." It also said that the pilot was experienced.

KEPNER AMBULANCE. The 1948 Henney Packard Ambulance was purchased to transport the sick and injured in the Wheeling and Martins Ferry areas. At one time Kepner owned three of these $16,000 vehicles.

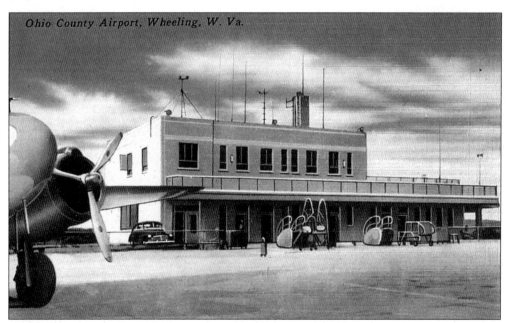

Ohio County Airport, Wheeling, W. Va.

OHIO COUNTY AIRPORT (STIFEL FIELD). In order to build this airport in the West Virginia hills, 4.5 million cubic yards of dirt had to be moved. Two runways of more than 5,000 feet in length were completed. In 1952, Presidential candidate Dwight D. Eisenhower met Richard M. Nixon in a second-floor office in the airport and after some discussion Ike reinstated Nixon as his running mate.

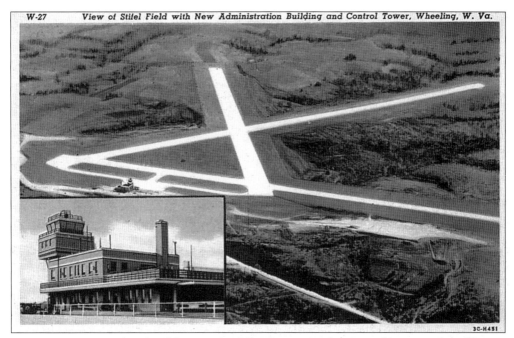

STIFEL FIELD. Mr. Edward Stifel, a prominent local executive, began working towards building an airport in 1931. It became clear that the board of commissioners was intent on holding up production. In 1938, Mr. Stifel circumnavigated the red tape by setting up his own association of wealthy citizens to personally guarantee $65,000 for the project. The airport was dedicated on November 1, 1946.

ENTRANCE TO GREENWOOD CEMETERY. In 1866, local investors purchased 37.5 acres for $11,120 in order to build a cemetery. Mrs. Caroline Morgan was the first interment on July 22, 1866. Since then another 100 acres have been bought and over 35,000 people have been buried there.

GREENWOOD CEMETERY, Wheeling, W. Va.

GREENWOOD CEMETERY. A large number of Wheeling's wealthy families are buried in this section. The large stately monument on the right is for Augustus Pollock, who established the Crown Stogie factories in 1871. He was known as a friend to the working man and proved it by leaving money in his will for the future education of his employees.

WHEELING HIGH SCHOOL ATHLETE. Weighing in at a slim 138 pounds is 1928 All-Valley lineman Alan Carney from Wheeling High School. This sparsely protected uniform was typical of that worn in the 1920s. All that is missing is his leather helmet which, of course, had no facemask. The unsafe conditions of playing football caused the President of the United States to force coaches to come up with safer equipment.

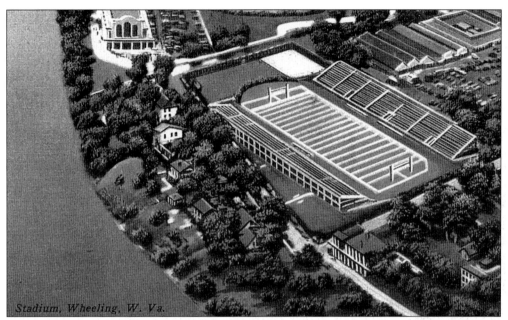

Stadium, Wheeling, W. Va.

WHEELING ISLAND STADIUM. The Wheeling Island Stadium was built in 1928 and has an unusual tale to tell, including the time when one of the "Flying Walendas" was killed here during a circus. The field has seen great players such as the Hall of Famer Lou "The Toe" Groza, Super Bowl V MVP Chuck Howley, Lance Mel, Nick Mumley, John Reger, Sam Wyche, and the movie star John Amos. President Franklin D. Roosevelt pressed hard for the New Deal inside the stadium. On September 24, 1952, President Dwight D. Eisenhower spoke to 8,000 people in the stadium to announce that he had decided to keep Sen. Richard M. Nixon on the ticket. The night before, Nixon had given his famous "Checkers" speech and his future on the ticket was unsure.

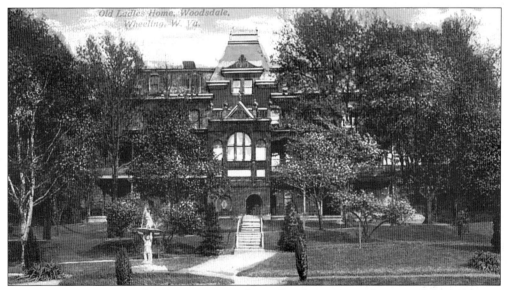

Old Ladies Home, Woodsdale, Wheeling, W. Va.

OLD LADIES HOME. This building was originally used as the Mount Belleview Hotel when it was built in 1878. In 1890, it became the Altenheim Home for the Aged. ("Altenheim" is German for "home of the aged.") The Altenheim business then took up residence in the Schenk mansion.

127

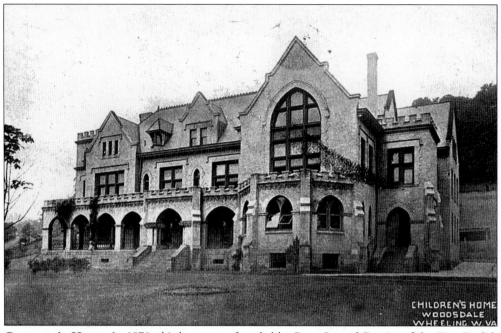

CHILDREN'S HOME. In 1870, this home was founded by Rev. Samuel Barnitz of the First English Lutheran Church and some local businessmen. It was established to meet the needs of families without fathers. The ground was broken for this building at 14 Orchard Road in 1901.

When I saw you in your khaki suit
You looked so brave and strong
As you marched away
from
Elm Grove, W. Va.
my heart just
went along.

WORLD WAR I DOUGHBOY. Postcards this were used to encourage enlistment for World War I. A grandmother in Elm Grove sent this one to her grandson in West Alexander, Pennsylvania.